chibi
Art Class

Inspiring | Educating | Creating | Entertaining

Brimming with creative inspiration, how-to projects, and useful information to enrich your everyday life, Quarto Knows is a favorite destination for those pursuing their interests and passions. Visit our site and dig deeper with our books into your area of interest: Quarto Creates, Quarto Cooks, Quarto Homes, Quarto Lives, Quarto Drives, Quarto Explores, Quarto Gifts, or Quarto Kids.

First published in 2019 by Race Point Publishing, an imprint of The Quarto Group, 142 West 36th Street, 4th Floor, New York, NY 10018, USA.
T (212) 779-4972 F (212) 779-6058 www.QuartoKnows.com

Race Point Publishing titles are also available at discount for retail, wholesale, promotional, and bulk purchase. For details, contact the Special Sales Manager by email at specialsales@quarto.com or by mail at The Quarto Group, Attn: Special Sales Manager, 100 Cummings Center Suite 265D, Beverly, MA 01915, USA.

10 9 8

ISBN: 978-1-63106-583-5

Project Editor: Erin Canning
Design and Page Layout: Laia Albaladejo
Illustrations: Yoai

Printed in China TT092020

chibi art class

A COMPLETE COURSE IN DRAWING CHIBI CUTIES AND BEASTIES

includes 19 step-by-step tutorials!

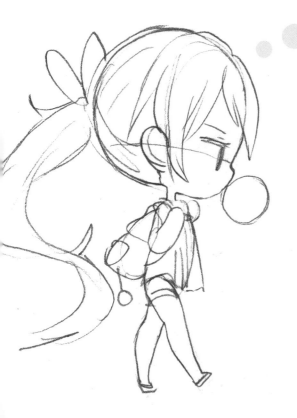

yoai

Race Point
PUBLISHING

contents

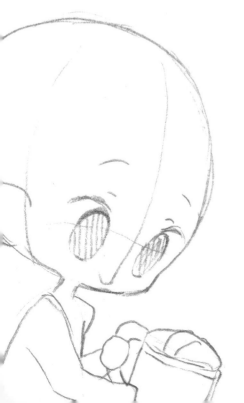

Introduction

hello!

My name is Anny and Yoai is my artist alias. I grew up making little doodles and whatnot, but I started taking drawing more seriously in 2012. The first things I drew were chibis, because I loved the style of them and they were easy to draw. After I began posting my chibi artwork on social media sites such as DeviantArt and Instagram, I began to explore and diversify what I drew. Today, I continue to draw chibis in addition to my anime-style drawings, and I share them online regularly on my social media accounts.

WHAT IS A CHIBI?

Chibis are mini versions of Japanese-style anime and manga characters. They are defined by their large heads and tiny bodies, both of which contribute to their *kawaii*, or cuteness, factor. In anime shows and manga comics, chibis are incorporated to deviate from the current mood or feeling of a scene, to make it more lighthearted, poke fun at it, or add comic relief. The drastic change in the art style and mood can show the characters in a more casual light, contributing a fun and interesting addition to the story. For example, characters may be having a serious conversation, when, suddenly, one of them cracks a joke, which prompts the scene to turn the characters into chibis, changing the tone of the conversation with the art style. Over the years, chibis have become more diverse, with many different styles of drawing them (i.e., variations in details, anatomy, art style, etc.). Essentially, chibis are kind of like stylized caricatures of regular anime characters; certain facial and anatomical features are exaggerated while maintaining the overall identifying appearance of the character. Here are some key characteristics of chibis:

- A small body and huge head—bodies can even be smaller than the head.

- Faces with huge eyes and small noses and mouths.

- The hands and feet can be exaggerated to give a more "cartoon"-style look.

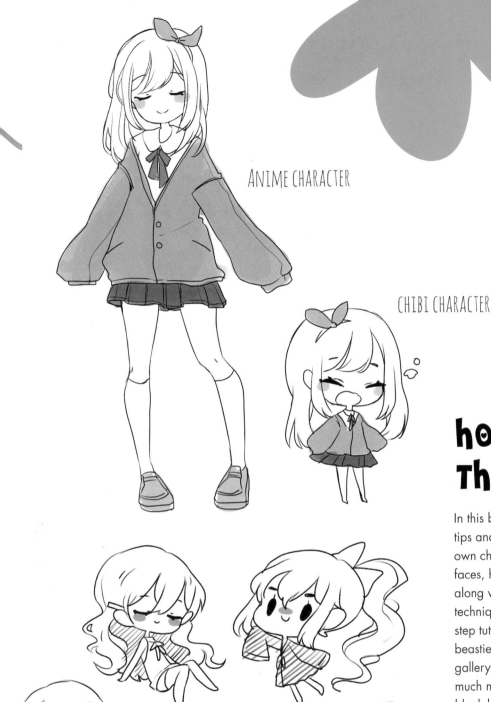

ANIME CHARACTER

CHIBI CHARACTER

how to use this book?

In this book, there are lots of tips and tricks for drawing your own chibis, including bodies, faces, hairstyles, and clothing, along with coloring and shading techniques; nineteen step-by-step tutorials of chibi cuties and beasties; and an inspiration gallery of hairstyles, clothing, and much more! Also included are blank body bases for you to start your own chibi drawings and coloring pages for you to practice coloring and shading. With that said, let's get started with our Chibi Art Class!

materials

getting STARTED

You don't need to invest in many materials to get started drawing your chibis. In this section, I have made suggestions, but feel free to experiment. These items can easily be found in the art section of your local craft store or online.

Paper

For illustrations with heavy color layering and shading, I prefer to use Canson Comic and Manga Illustration Bristol, which is a heavyweight paper. For illustrations with single-layer coloring and blending, I like Canson XL Mix Media, which is a mid-weight paper that can be used with a variety of mediums.

markers

Markers are my go-to for coloring chibis. They are simple to use and versatile, especially brush-tip markers. For the art in this book, I used a mix of brands of alcohol-based markers (see page 10), spanning a range of prices, from the expensive Copic and Touchnew markers to the budget-friendly Bic Marking (set of 36) and Crayola Signature Blending (set of 16) markers. Though my step-by-step tutorials list specific marker types and colors, feel free to substitute what you like.

Alcohol-Based Markers vs. Water-Based Markers

For the art in this book, I primarily used alcohol-based markers. You can use water-based markers; however, there are some key differences between the two types. Though water-based markers are nontoxic, washable, and cheaper, the result will differ from that of alcohol-based markers, the most noticeable being when applying a solid color and when blending two or more colors. When applying a solid color, water-based markers tend to leave streaks and overlaps, while the resulting color of alcohol-based markers is (mostly) smooth. When blending, water-based markers are difficult to blend and leave obvious "choppy" borders, while alcohol-based markers are easily blended for a smooth, seamless look.

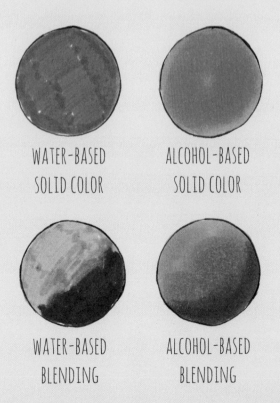

WATER-BASED
SOLID COLOR

ALCOHOL-BASED
SOLID COLOR

WATER-BASED
BLENDING

ALCOHOL-BASED
BLENDING

Fineliner Pens

Fineliner pens are an artist's staple and perfect for outlining your art. They come in a variety of colors and nib sizes for different line weights and are easy to use. Be warned, however, that if you want to outline or color your chibi with a fineliner, use one that is waterproof, or your lines become smudged when you add in color with marker or colored pencil. I like to use the Sakura Pigma Micron 0.1mm in black. If coloring your chibi with watercolors instead of markers or colored pencils, outline your chibi with pencil (regular or waterproof colored pencil) instead (never use pencil with marker).

Watercolors

Watercolors are slightly more difficult to work with than markers when coloring your chibis, as it is harder to control the opacity and consistency of the color. However, overall, it offers much more variety in colors as color-mixing allows you to create any color imaginable, unlike markers. I like using the Sargent Watercolor Art-Time Pan (8-color set) and its accompanying brush. Remember to rinse and dry your brush every time you change colors.

erasers

There are two types of erasers you will want to have on hand when you are using a pencil to make a rough sketch of your chibis: a white plastic eraser, such as a Pentel Hi-Polymer eraser, and a gray, kneadable eraser, such as a Prismacolor Kneaded Rubber eraser. The plastic eraser will erase and obliterate everything in its path, while the soft, kneadable eraser is better for selective erasing, such as removing soft shading. Here, I have made a couple sketch patches with an "X" in the middle. The white plastic eraser erased everything, while the gray, kneadable eraser erased the shaded background but not the "X."

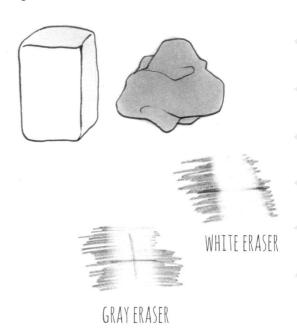

WHITE ERASER

GRAY ERASER

pencils

Before you begin drawing and coloring your chibis, I suggest using a pencil to make a rough sketch, so you can erase any mistakes. I like using a wood HB pencil (any brand), with a lead that is not too dark or too light. Colored pencils are a great way to add soft colors and shades into your artwork; however, if you want a more solid color when using colored pencils, you will need to press harder onto the paper when coloring. I prefer Prismacolor colored pencils (set of 24).

white gel pen

This pen is great for adding details and highlights to your chibis. If you find it to be too opaque when used on an illustration, you can slightly scratch it with your fingernail to remove some pigment, but only if it has completely dried; otherwise, it will smudge and ruin your drawing! I like to use the Uni-ball Signo gel pen.

Additional Tools

Pencil sharpener: Keep your pencils sharp with a high-quality pencil sharpener that isn't made of flimsy plastic. Additionally, the blade tends to wear down after frequent use, so ensure that your blade is sharp or it will damage your pencil.

Ruler: Use a ruler that is at least 12 inches (30 cm) long. Do not use a folding ruler, as most don't line up perfectly when straightened out.

ChIBI BASICS

Are you ready to learn how to draw chibis?! This section is chock-full of information to get you started, including how to draw bodies, faces, hairstyles, clothing, and props and backgrounds, along with coloring and shading techniques. There are even a couple practice step-by-step tutorials! Refer back to this section whenever you need a chibi how-to refresher.

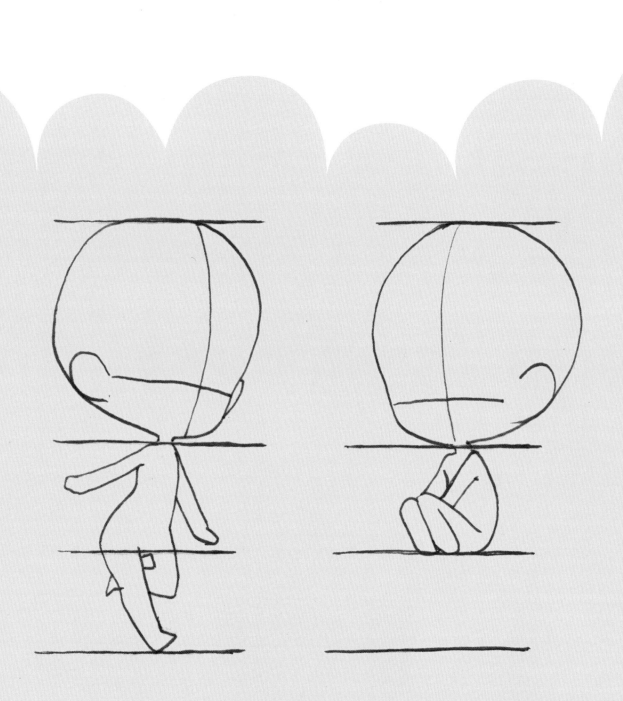

sketching your chibis

Before you begin drawing and coloring your chibis, you should do rough sketches of them first—ink is permanent, but pencil can always be erased! A good sketch makes for a great foundation for your drawings.

BODIES

Unlike regular Japanese anime and manga characters, chibi characters do not have realistic proportions, having more in common with cartoon characters in terms of size and shape, with their large heads and tiny bodies. In this section, I will show you how to draw the proportions and body types for your chibis.

You do not have to make every chibi two "heads" tall. Here are examples of one that is one-and-a-half "heads" tall and one that is three "heads" tall. You can adjust the head and body proportions to your liking.

components

As you will see with my illustrations throughout this book, the components that make up a chibi's body are simple to draw and usually consist of a large oval head, small trapezoid-shape torso, simple arms and legs (and hands and feet!), thin neck, and arcs off the sides of the head for ears. Once you have this simple base down, you can then play with their proportions, poses, and looks. There's no limit to what you can do with chibis!

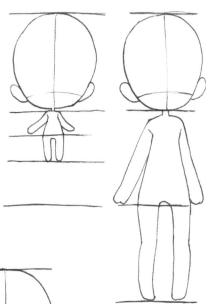

proportions

A good rule of thumb when drawing a chibi is that the body should be roughly the same length as the head. Use the head of the chibi as a unit of measurement when planning out the proportions of your character, like I've done here. This chibi is two "heads" tall, with the body being the same length as the head.

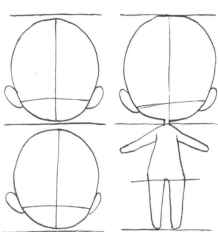

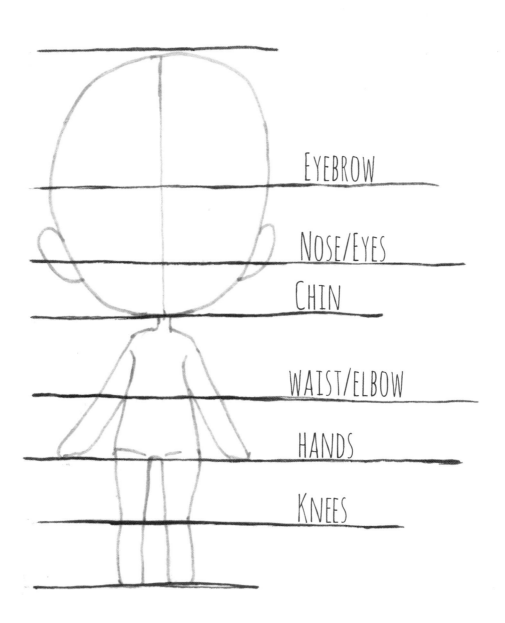

EYEBROW

NOSE/EYES

CHIN

WAIST/ELBOW

HANDS

KNEES

A more precise way to measure out the body proportions is by making checkpoints at different parts of the body. First, indicate the lines for the top of the head, bottom of the feet, and bottom of the chin before adding the others. These are visual parameters to ensure your chibi character is the size that you intended it to be.

If you want your chibi to have an action pose, you can still use the checkpoints to measure the proportions (page 15). Here are a few examples.

BODY TYPES

When drawing the torso and limbs, there are many different body types to choose from. Here are the four that I use most often.

Thin: These chibis have lean limbs and torsos, and are a good base for adding puffy or loose clothing.

Medium: These chibis have well-rounded bodies for any kind of clothing.

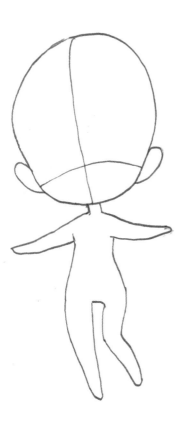

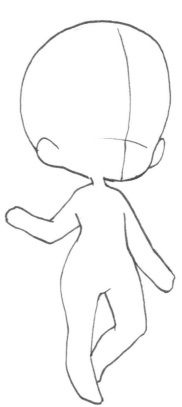

17

Larger lower: These chibis have longer, thicker legs, perfect for showing off clothing with more detail on the bottom, as well as shoes.

Tall: These chibis' bodies have more surface area to work with and are the best type for emphasizing clothing details.

FACIAL FEATURES

The face is, no doubt, the first thing that draws your eyes to a chibi drawing (no pun intended!). In this section, I will show you how to place facial features, along with tips on showing expression through the features.

Proportions and Placement

As with the method used to make proportional checkpoints for the body (page 15), the same rules can be applied to positioning features on a face, including the start of the hairline, eyebrows, base of the eyes and nose, mouth, and chin. When adding these guidelines, work from the outside in. It also helps to draw a vertical line down the center of the face to establish where the nose will go. If the character is facing to the right or left, then the vertical line should be slightly to the left or right of center.

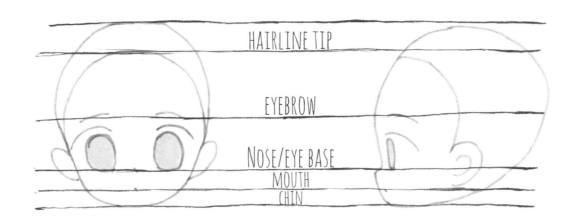

HAIRLINE TIP

EYEBROW

NOSE/EYE BASE
MOUTH
CHIN

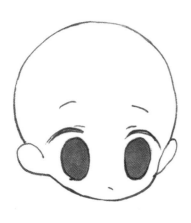

YOUNGER

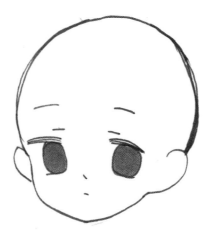

OLDER

The placement of facial features can also emphasize a character's age. Placing the features lower on the face and closer together will make your character look younger, while placing them higher and farther apart will make them appear older. Making the eyes bigger also contributes to a more youthful appearance.

eyes

The eyes can be one of the hardest things to draw on the face, and yet the most important. A good tip to remember is that the distance between the eyes should be the width of one eye. For a straight-on view, the eyes should be the same size; on a tilted face, the iris of the eye farther away from view should be about half the width of the nearer eye, and even smaller, the farther the head is tilted to the side. See the Inspiration Gallery on page 126 for lots of cool eye styles!

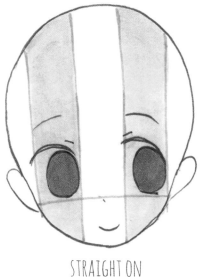

STRAIGHT ON

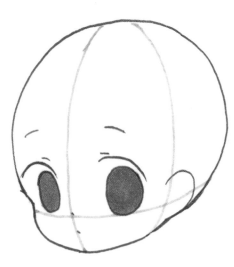

TILTED

Perspective also affects the shape of the eye. For a straight-on view, there is no dramatic shifting of the iris within the eye. If the viewing angle is from the bottom, the iris will shift lower on the eye, exposing the white of the eye to the top of the iris. The opposite is true if the viewing angle is from the top.

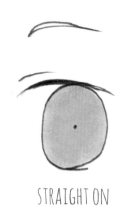

STRAIGHT ON

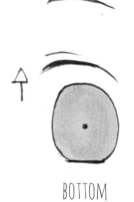

BOTTOM

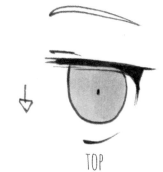

TOP

Eyes might just appear to be simple circles, but there are actually a lot of components to them, with many ways to draw them. Japanese anime and manga eyes resemble realistic eyes, but with some features exaggerated or removed. Here is a comparison of a (somewhat) realistic eye and an anime eye. The most notable difference is the iris—the anime one is huge! The entire eye itself is narrow and vertically long, and the corners and tear ducts are nowhere to be seen. The eyelashes are more defined and clumped together, and the eyebrow is simplified. There is also a large distance between the brow and the eyelid.

shine

The shine of the eyes should be consistent with the light source. While you should add a main "shine" point to the eye reflecting the light source, additional shine can be added with a white gel pen for cosmetic effect.

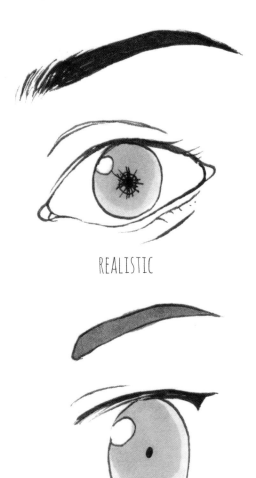

REALISTIC

ANIME

There are also a few differences between an anime eye and a chibi eye. Chibi eyes should ideally be longer, have larger irises, and smaller eyebrows to add to the cuteness factor.

ANIME

CHIBI

The shape of the eyelids can cover different amounts of the eye and also affect the expression. When drawing eyelids, the fold should appear as a crease above the lash line; it can either go along the whole length or just start at the inner corner of the lash line. If eyes are half open, the crease can be drawn lighter for a more realistic effect. Here are examples of different eyelid shapes, the arrows indicate which directions to draw the lash lines.

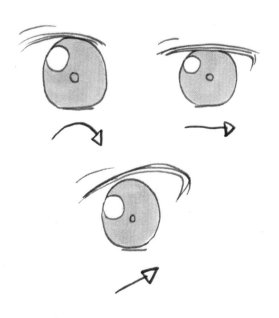

Eyebrows should always be drawn starting from the inner corners (from the nose) outward (to the sides of the head). Here are examples of different shapes for eyebrows.

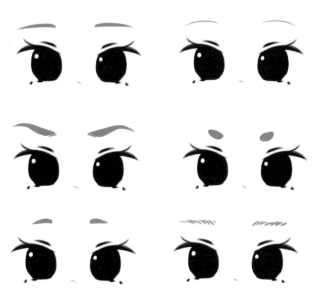

Let's not forget the side view! The same rules apply when drawing an eye, but you want the general shape to be a flat side for the iris with a curved top and bottom for the top and bottom lids.

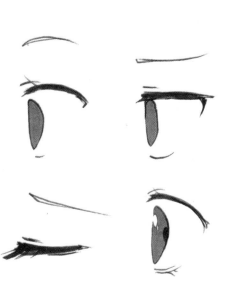

Here are some different shapes and designs of eyes for inspiration. Try drawing them or adding them to your own chibi drawings!

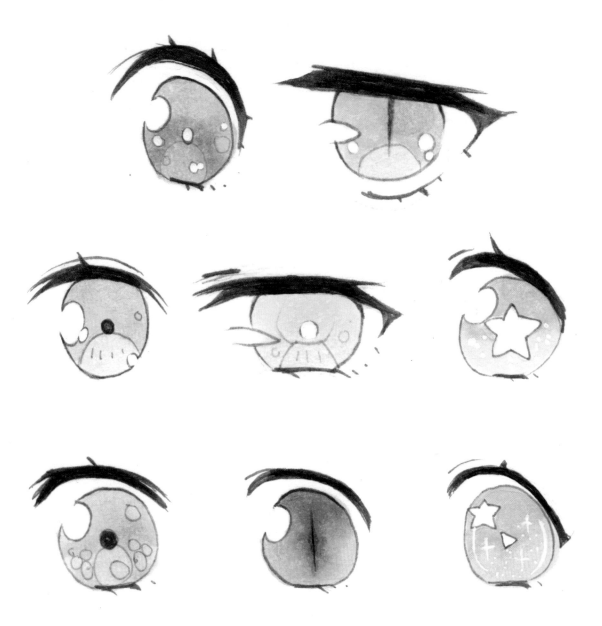

noses

Here are a few examples of noses, though in some cases drawing a nose is unnecessary if you prefer to add in the contour of one when shading instead.

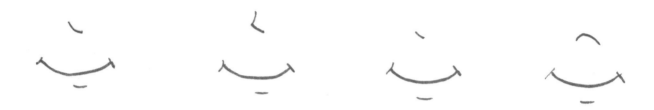

mouths

When drawing the mouth, don't forget to add teeth or a tongue for a more realistic look, instead of just what appears to be an endless void through a hole in the middle of their face. The tongue should be a shade lighter than the inside of the cheek to add more depth. Don't forget to add a crease below the mouth for the bottom lip.

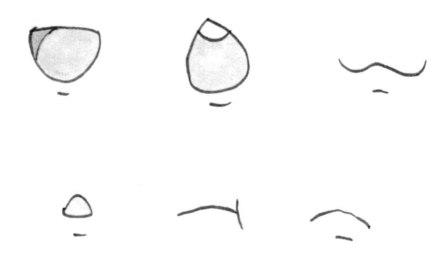

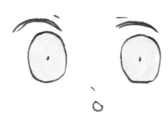

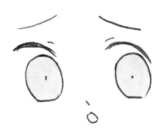

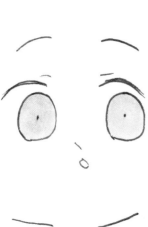

expressions

Certain features should not be left out if you want your character to be expressive. The most important ones to keep are the eyebrows and the mouth. Here are some examples of how changing the eyebrows or mouth can affect the expression and emotion of your chibi character.

hAIR

Just like our hair is an important way of expressing ourselves, hair for chibi characters does the same thing! Hair can be long or short, curly or straight, tied up or loose—anything you desire! Don't forget to check out the Inspiration Gallery on page 129 for hairstyle ideas.

TexTure

In order to simplify the process of drawing hair strands, you can draw in the general shape of the hair first before adding in details.

Make the strands vary in width; they will look more realistic and give the hair depth, rather than looking like a squiggly tube or ramen noodles.

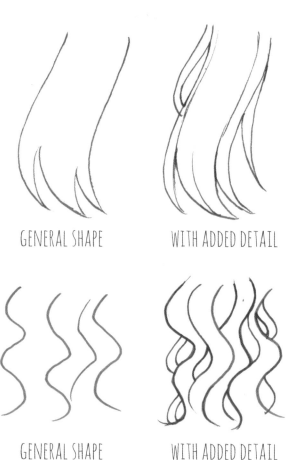

GENERAL SHAPE · WITH ADDED DETAIL

GENERAL SHAPE · WITH ADDED DETAIL

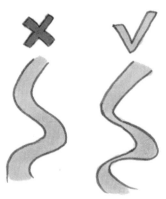

When drawing hair, remember that not every strand is on the same plane, meaning there is hair in the front as well as the back. Because the hair in the back is farther away, you don't have to define individual strands. Also make it a darker shade than the hair in the front, as the light source is not going to be hitting it directly.

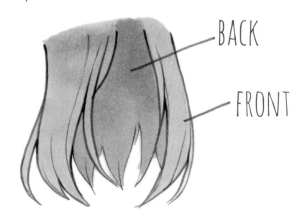

BACK

FRONT

Technique

Have you ever wondered where to start when drawing hair? In order to prevent hair from looking like a cheap party wig that you slapped on your chibi, you should ensure that the hair is branching out from one or more points of the scalp. Here, the blue line serves as the hairline. This means that everything above this line is the scalp, where hair can "grow" and branch out from, and the area below this line is the head, where hair can fall over and overlap. Here are some different ways the hair can "grow" and branch out from your chibi's head.

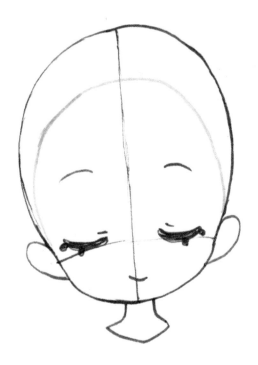

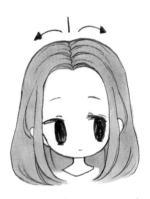

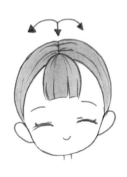

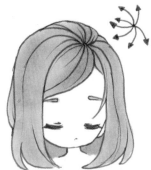

Here, the hair parts and branches out to the sides from the center of the head.

This hairstyle parts in the center; however, there are bangs, so it comes from the same parting, just in a different direction than the sides

Instead of having hair parting from a straight line, you can also have it part from a single point. Here, the hair branches out from a point and spirals outward.

You can put a part anywhere in the hair!

REGULAR

CLOThING

Clothes and shoes help give chibis their "character," but these things can also be a bit of a challenge to draw, since chibis have small bodies and tiny feet. Don't forget to check out the Inspiration Gallery on page 132 for fashion ideas.

Clothes

Even though chibis have small bodies, this doesn't mean their clothes have to be small too. Clothes can be drawn loose-fitting to make the chibis look bigger and to give the "fabric" flow. Doing this also helps balance the body with the large head.

LOOSE

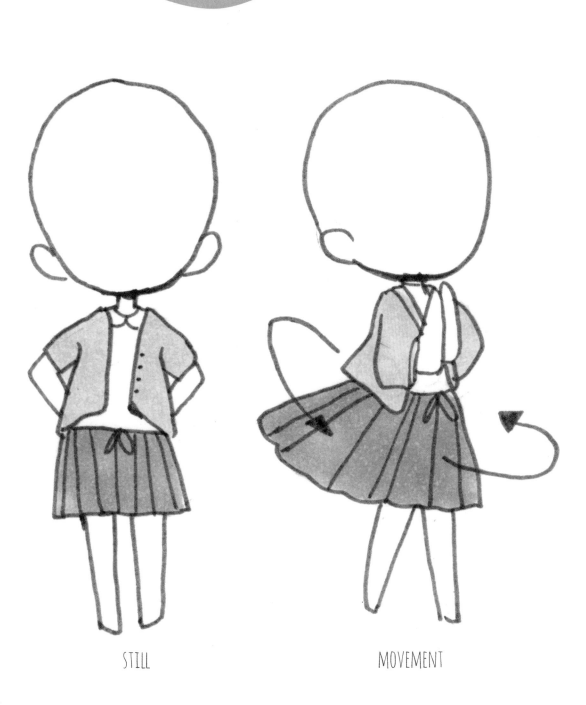

STILL

MOVEMENT

When your chibi character is in motion, remember that the clothes will move with them (unless the clothes are meant to be tight).

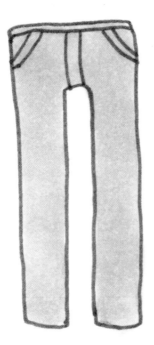

A good way to add details to pants and avoid having them looking like tubes is to add seams along the sides and creases at the knees and ankles, as the pants will be looser in these areas since they are narrower than the rest of the leg.

NO SEAMS AND CREASES

SEAMS AND CREASES

When drawing clothing that folds over itself, remember to maintain a flow to the shape of the clothing and add shading to the parts that avoid the light source.

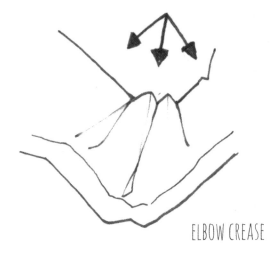

A sleeve should have creases where the elbow is bent inward, so follow the direction of the elbow bend to create creases in the cloth.

Here are some examples of clothing folds with arrows indicating the direction of the creases. A twisted sleeve pulls in one direction. An elbow crease fold branches from the point from the inside of the elbow where the upper arm and lower arm touch. Cloth pinched or tight at the top should fan out and downward.

ELBOW CREASE

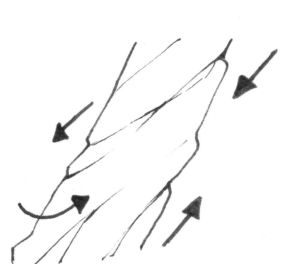

TWISTED SLEEVE

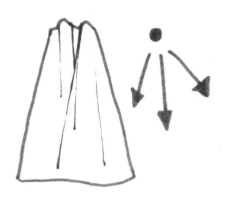

PINCHED CLOTH

To create a more dynamic look to clothing, openings should not be drawn flat, but with a twist.

When you are drawing an open coat, it can be hard to figure out how it will fit your character. If you simplify it by converting it to a simple shape before adding details, it will be much easier. Here, the basic shape of the coat's body is drawn before adding in details such as sleeves and buttons.

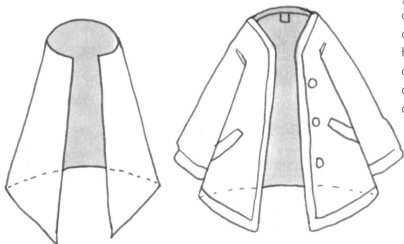

shoes

Chibi characters have tiny feet, so drawing shoes can be quite a challenge. There's hardly room to indicate where the toes are, much less figure out how to fit a shoe on a foot! Even though chibis' feet are small, the heel and toe can still be highlighted. Here, the heels and toes are marked in blue on a wide chibi foot and a thin one.

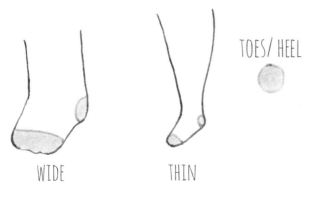

TOES/ HEEL

WIDE THIN

Once you know where the heel and toe of the foot are, you can start drawing a shoe. A good method is to start drawing it from the heel and form the shoe around the entire foot. Here are some examples.

Here is the basic shape of a shoe—a sole and a cover to wrap around the top of the foot. The shape of the shoe also depends on the sole, which in turn depends on the shape of the foot.

PROPS AND BACKGROUNDS

In order to bring your chibis to life, you can add some props and/or backgrounds for them to interact with. Here are some tips on how to suspend reality and make your chibi drawings more engaging. Don't forget to check out the Inspiration Gallery on page 135 for prop ideas.

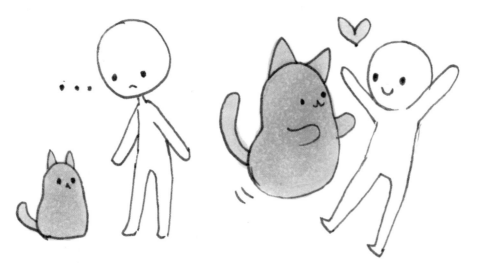

PROPS

The chibi world doesn't have to shrink to match a chibi's size. When this cat is drawn in proportion to the character, it is kind of boring, right? But when the cat is bigger, there's some meaningful interaction!

Who would choose a tiny ice cream cone when you can have a giant one?!

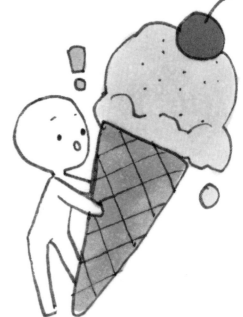

Another reason to draw big props is to help fill empty space, especially if you don't want to add a background. You can also include many props!

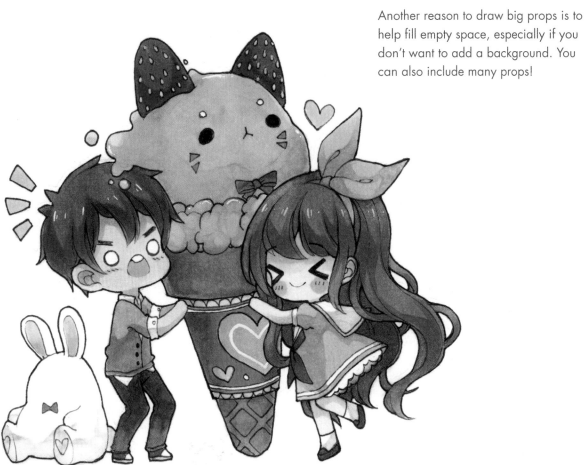

Backgrounds

Another way to fill empty space is to add a background. You don't want your chibi to be all alone in an endless white void, do you? Like with props, the background doesn't have to be realistic—even a simple pattern will do.

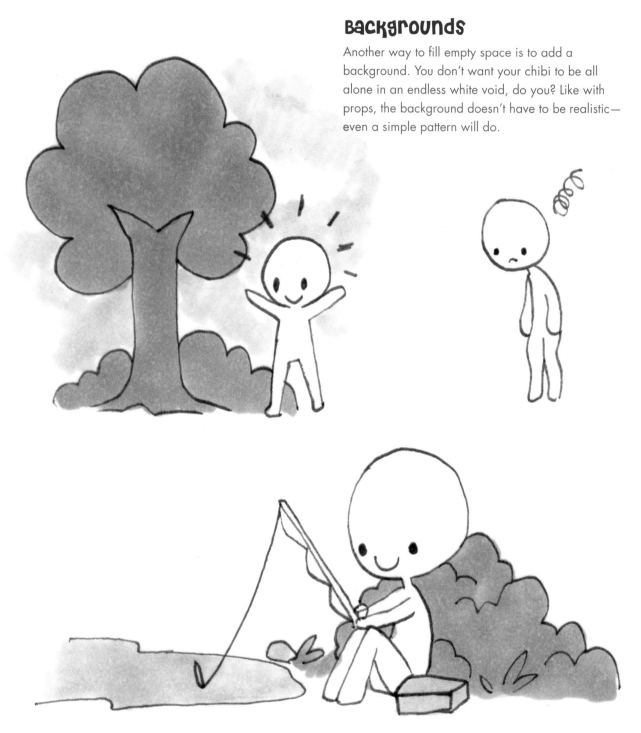

This fishing scene is an example of a partial background, with an interactive foreground. It is always a good idea to think of the full scenario before you begin sketching your chibi to ensure that the chibi's pose fits with the chosen environment.

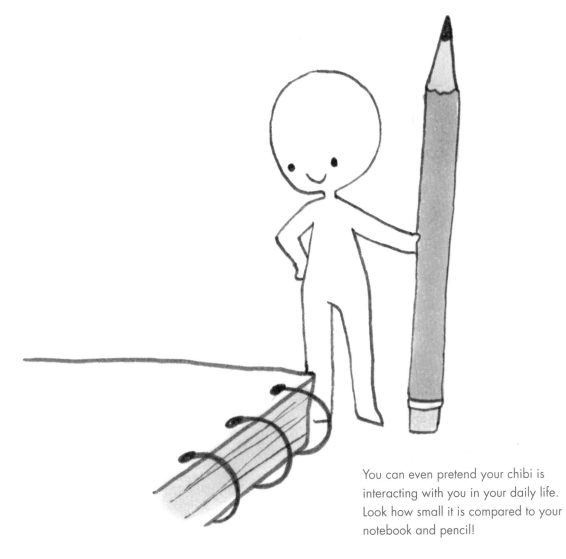

You can even pretend your chibi is interacting with you in your daily life. Look how small it is compared to your notebook and pencil!

shading Basics

Adding shading to your chibis is just as important as coloring them. Shading adds depth and volume to your drawings and helps bring them to life. In this section, we will explore some basics of shading to achieve an overall understanding. (This is a general tutorial for practicing with pencil. For shading with color, see Coloring Your Chibis on page 42.)

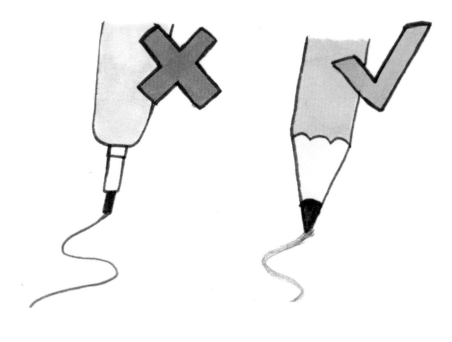

pencils

It is my recommendation that mechanical pencils not be used for shading. The graphite leads of mechanical pencils are made hard to prevent flaking and chipping, and as a result, they only make solid, thin lines. You also cannot adjust the thickness of your lines by tilting the pencil, and the hard lead can leave a noticeable dent in the paper, which will linger even after erasing the line. The graphite leads of wooden pencils are much softer, allowing you to draw a variety of lines of different densities and thicknesses. They also can be more easily erased and do not damage paper. While the leads of wooden pencils can flake and chip, these "flaws" can easily be used to your advantage when shading, as they provide more graphite on the paper to blend around.

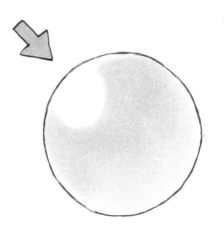

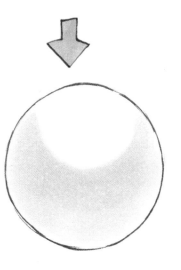

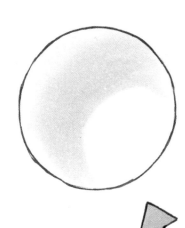

Light source

Before you begin shading, it's important to establish a consistent light source for each element of your drawing. For each of these spheres, the blue arrows indicate which side the light is coming from.

The spot that the light is hitting on this sphere is white; the area around it, where the shading is, is not being hit by the light source. The shading should be darkest closest to the highlighted area, slowly softening and fading as it moves farther away.

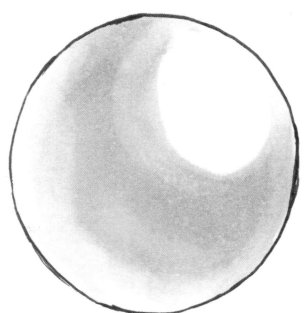

shading Techniques

Here are the three easiest techniques for shading with pencil.

Straight lines: Tilt your pencil and make diagonal lines in one direction, filling up the area you want to shade. This is a quick and easy method of shading and provides a light feel to your artwork. It is also a good method for amplifying actions or movement.

Crosshatching: After shading with the straight-lines technique, repeat drawing diagonal lines in a different direction. The lines do not need to be perpendicular to the first set. Crosshatching creates a more solid look than straight lines.

Solid shading: Using a pencil with a blunt tip, hold the pencil vertically and press lightly in a circular motion around the area you want to shade. It is very important to not press too hard, as you will need to go over the area multiple times. This technique is more time-consuming than the other two methods, but it will provide a clean, consistent, and soft patch of shading.

shadows

When there is an object between the light source and another object, the object in front will cast a shadow onto the object behind it. The shape of this shadow should be consistent with the object it came from. For example, this sphere is casting a circular shadow onto the rectangle behind it. The light source is indicated with the blue arrow.

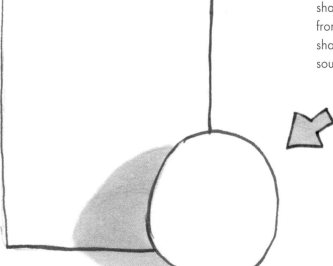

When shading objects with different textures, the shadow will also be affected. Here, the shadow on the strands of hair follows the flow of the hair, and the shadows on the sleeve follow the folds of the clothing.

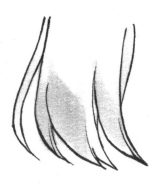

coloring your chibis

Now that you understand shading basics, it's time to add color to your chibis. Here's where you can really have fun with your chibis and experiment with color. The step-by-step tutorials following this section will guide you even further with this process!

COLOR

Certain colors complement each other, whether they are contrasting or not (by "contrasting," I'm referring to two colors with a significant difference in tone or that are far apart on the color spectrum, such as black and white or red and indigo blue). Colors that are on opposite sides of the color wheel are complementary colors, such as red and green, orange and blue, and yellow and purple. When used together in an illustration, complementary colors can overwhelm the artwork, so use a lot of one color with a small "pop" of the other color, or use a tint of one of the colors if you want to feature both colors. Here's a color wheel for your reference to see which colors are complementary. And don't be afraid to experiment with color to come up with your own unique color combinations!

warm. cool. and neutral colors

Colors often fall into three categories: warm, cool, and neutral. Warm colors are easy on the eye and give a feeling of "warmth," and include colors such as red, orange, yellow, and brown. Cool colors are bolder and more striking, and include colors such as blue, green, cyan, purple, and indigo. Neutral colors, also called tones, are black, white, and all shades of gray in between.

SHADING

Here, I've included my method for adding color shading to your chibi art. These are my preferences, but feel free to experiment to find what you like. I like to use cool colors for shading any color. I find that blues and purples work universally well as a shadow color (exceptions are warm yellow and orange, because they are too far on the warm end of the spectrum). When adding shading, you don't always have to use a darker version of the base color. Using a slightly different color will give your art more liveliness and make it look less "flat." When shading,

the left side should have the base color and the right side the shading color (assuming the light source is a white light coming from the top-left side). Here are some color combinations (base color and shading color) that I recommend.

base color	shading color
red	red-purple
orange	brown
yellow	orange, light pink, beige
green	blue-green
blue	purple
purple	indigo
indigo	deep purple
pink	purple
brown	purple
white	pale blue, lavender, color most dominant in object's surroundings
pastels	lighter versions of colors above

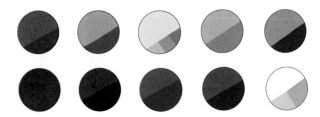

BLENDING

Whether you're mixing colors together to create a new color or are adding shading, here's how to seamlessly blend your colors together when using markers, colored pencils, and watercolor paints.

markers

When blending together two colors, always use the lighter of the two to blend. Blend with downward strokes; circular strokes can cause the ink to bleed (spread). "Blender" or "clear" markers will significantly lighten the color, so only use if dispersing a single color around; they are not for blending two or more colors together.

colored pencils

When blending together two colors, always use the lighter of the two to blend. Blend in a circular motion with moderate pressure; otherwise, streaks will appear and you could make dents in the paper. Use a white pencil to blend and smooth out colors, though doing this will make the colors lighter.

watercolor

When using watercolor paint, you can only fully blend colors while the paint is wet. If you must blend a color that has already dried on the paper, re-wet that color with a small amount of water before adding the new color. Watercolor strokes can streak if the brush is too dry, so make sure it's damp. Blend in a circular motion to help prevent streaking. If you have trouble blending with the brush because there is excess water, try blending using a cotton swab or paper towel. Doing this absorbs the extra water while providing a texture to move the colors around with.

gradient

When you apply a gradient, you're applying color that goes from being darker to lighter. If making a gradient with two colors, lay down the lighter color first for the entire area that you are coloring, and then use the darker color on top of the lighter color only in the area you want darker; blend with the lighter color. If using three or more colors, lay down the colors from lightest to darkest, and then use the darker colors on top of the lightest color only in the areas you want darker; blend with the lightest color.

practice chibis

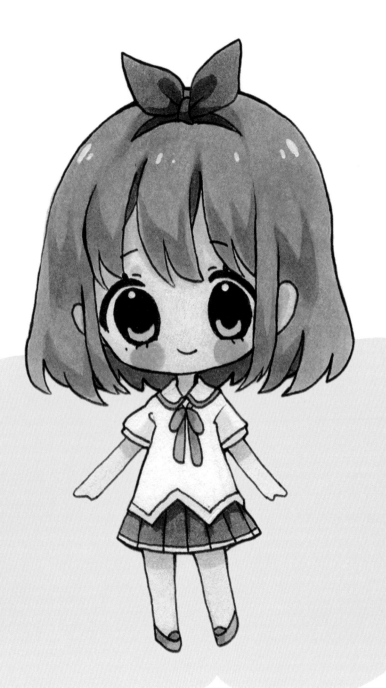

Ava

It's Ava's first day of school, and she has mastered the innocent "puppy dog" look! Let's hope she can charm her way into the hearts of her classmates and instructors.

materials

♥ Pencil

♥ Eraser

♥ Black Sakura Pigma Micron 0.1mm fineliner

♥ Copic markers: Skin White (E00), Baby Skin Pink (E21), Mauve Shadow (BV00), Frost Blue (B00), Sea Green (G12), Blush (R20), Barley Beige (E11), Pale Lilac (V12), Powder Blue (B41), Soft Violet (BV11)

♥ White Uni-ball Signo gel pen

1 Using a pencil, draw a large oval for the head and a trapezoid for the body—Ava is facing forward.

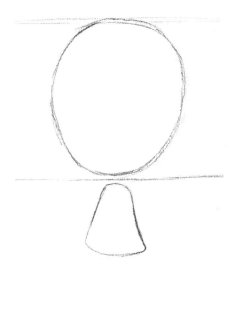

2 Draw Ava's arms and legs, with her arms straight out from her sides and her legs in a standing position, with her toes pointed inward. Add the guidelines for the face and the neck and ears.

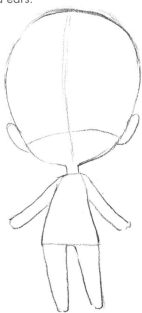

3 Sketch in her face—let's give Ava a happy expression, as she is excited about going to school.

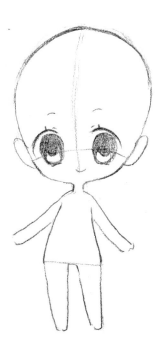

4 Ava needs some hair and clothes to complete her look! Let's give her thick, straight, short hair with long bangs and a ribbon headband. She wears a school uniform of a short-sleeve, sailor-style blouse, pleated skirt, and loafers.

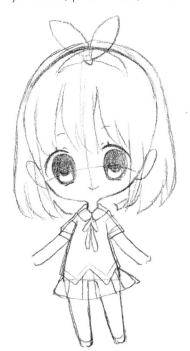

5 Our sketch is messy—clean it up with your eraser! Add more details, such as clothing folds and seams and strands of hair.

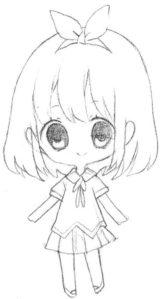

6 Using your fineliner, go over your pencil lines. Draw in the lines, making sure to vary the thickness to add more depth. When drawing the hair, press lighter toward the ends of the strands. Make sure the ink is dry before you begin erasing.

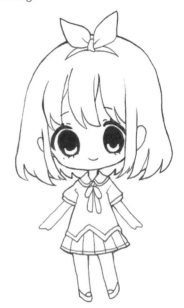

7 Let's add some base color! Color Ava's skin with the Skin White marker and her hair with Baby Skin Pink. Use Mauve Shadow for her skirt, headband, and piping around her shirt collar and Frost Blue for her shoes and shirt bow. Finally, color her irises with Sea Green.

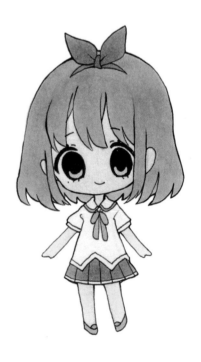

8 Now that we have the base color down, let's add some shading. Use the Blush marker where Ava's hair and clothing meet her skin. Also color her cheeks with this color. Apply shading with Barley Beige on her bangs, the underside of her hair and where the bangs fold over themselves, and around the headband. Use Pale Lilac to make a gradient of the shaded parts of her hair only, and then completely go over the underside of the hair and where it folds over itself at the bangs. Add shading to her shirt with Powder Blue and use Soft Violet for her skirt and headband. Use Mauve Shadow to shade in her shirt bow and shoes. Finally, use your gel pen to add highlights to her hair and eyes.

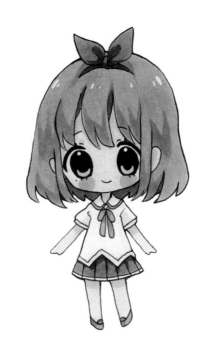

DRAW YOUR OWN!

Bonnie

Ava's older sister, Bonnie, has done the school thing for a while now. She drinks soda to keep her alert during the most boring lessons.

materials

- Pencil
- Eraser
- Black Sakura Pigma Micron 0.1mm fineliner
- Copic markers: Skin White (E00), Baby Skin Pink (E21), Robin's Egg Blue (B02), Apple Green (G14), Prawn (R24), Blush (R20), Pale Lilac (V12), Light Hydrangea (B63), Toner Gray No. 1 (T1), Amethyst (V17)
- White Uni-ball Signo gel pen

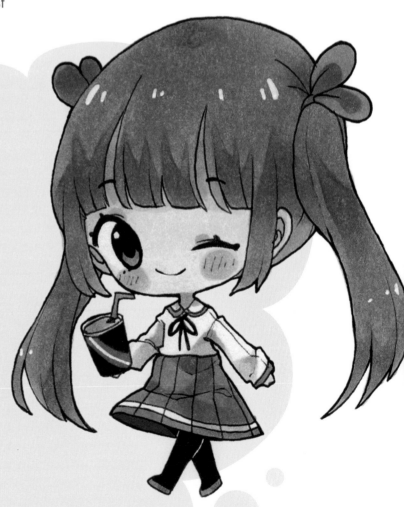

1 Using a pencil, draw a large oval for the head and a trapezoid for the body—Bonnie is facing to the left (well . . . *your* left and her right) but looking straight at you.

2 Draw Bonnie's arms and legs, with her left arm straight out from her side, her right arm slightly bent with the palm up to hold a soda can, and her legs in a walking position, with the left one crossed in front of the right one. Add the guidelines for the face and the neck and ears.

3 Sketch in her face—let's give Bonnie a look of confidence (note the wink!), as she's now one of the older students at school.

4 Bonnie needs some hair and clothes to complete her look! Let's give her thick, straight hair with blunt bangs and loose tendrils. Her hair is tied into pigtails with ribbons. She wears a school uniform of a long-sleeve, sailor-style blouse, pleated skirt, tights, and loafers. Add some "bounce" to her skirt and a soda can in her right hand.

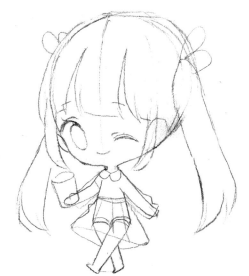

5 Our sketch is messy—clean it up with your eraser! Add more details, such as clothing folds and seams and strands of hair. Don't forget the straw in her soda can and the can design!

6 Using your fineliner, go over your pencil lines. Draw in the lines, making sure to vary the thickness to add more depth. When drawing the hair, press lighter toward the ends of the strands. Make sure the ink is dry before you begin erasing.

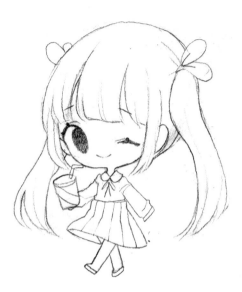

7 Let's add some base color! Color Bonnie's skin with the Skin White marker and her hair with Baby Skin Pink. Use Robin's Egg Blur for her skirt, shoes, hair ties, piping around her shirt collar and cuffs, and the straw in the soda can. Color her eyes with Apple Green. Finally, use Prawn for the stripe on the soda can.

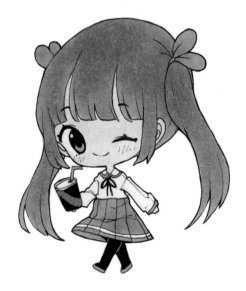

8 Now that we have the base color down, let's add some shading. Use the Blush marker around Bonnie's bangs, for her cheeks, and in her ears. Apply Pale Lilac in the upper creases of her bangs, around her eyes, and on her neck. Use Light Hydrangea to shade in her skirt, hair ties, and shoes and Toner Gray No. 1 and Pale Lilac for her shirt and the top of the soda can. Add shading to the inside of her skirt with Amethyst and use Pale Lilac for the skirt's white stripe. Finally, use your gel pen to add highlights to her hair and eyes.

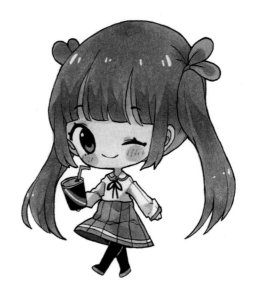

DRAW YOUR OWN!

chibi cuties

The chibis in this section are not only cute, but each one represents a different month of the year! Have fun learning how to draw these chibis as they celebrate holidays and the changing seasons, from January to December.

Jamie
January

Kick off the start of the New Year with some fireworks! Of course, Jamie is being safe and using sparklers instead.

materials

- Pencil
- Eraser
- Black Sakura Pigma Micron 0.1mm fineliner
- Bic Marking markers: Sunset Orange, Summer Melon
- Copic markers: Lapis Lazuli (B18), Light Suntan (E13), Toner Gray No. 1 (T1), Powder Blue (B41), Pale Cherry Pink (R11), Skin White (E00), Pale Lilac (V12)
- Crayola Signature Blending marker: Polynesian Purple

1 Using a pencil, draw a large oval for the head and a trapezoid shape for the body—Jamie is facing to the left (well . . . *your* left and his right side).

2 Draw Jamie's arms and legs, with both arms bent upward to hold a sparkler and the legs in a standing position. Draw the (unlit) sparkler too! Draw a rectangle on the ground next to Jamie—this will be a box that holds fireworks. Add the guidelines for the face and the neck and ear.

3 Sketch in his face—let's give Jamie an expression of amazement, as he will be looking at a lit sparkler.

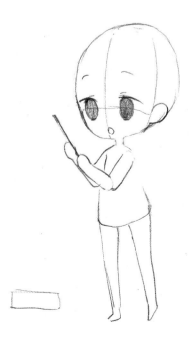

4 Jamie needs some hair and clothes to complete his look! Let's give him thick, straight hair. He wears a sweater, jeans, and a leather coat and shoes. He also needs round wire glasses. Add the sparkle to the sparkler and define the shape of the box, drawing in additional fireworks.

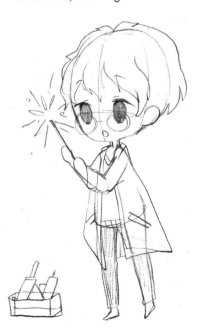

5 Our sketch is messy—clean it up with your eraser! Add more details, such as clothing folds and seams and strands of hair.

6 Using your fineliner, go over your pencil lines. Draw in the lines, making sure to vary the thickness to add more depth. When drawing the hair, press lighter toward the ends of the strands. Make sure the ink is dry before you begin erasing.

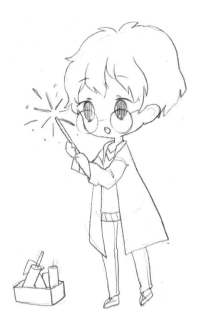

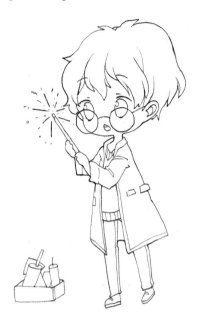

7 Let's add some base color! Using an equal blend of the Bic Sunset Orange and Summer Melon markers, color in Jamie's coat, irises, and the box. It will be easier to blend if you lay down Sunset Orange first, as it is a darker color that you can dilute with the Summer Melon. Individually using these markers, color in some of the fireworks in the box (as shown). Summer Melon can also be used to color in the sparkles of the sparkler. Color in Jamie's skin, starting from the outside in, avoiding the whites of the eyes—be heavier with the color where his hair touches his face and lighter toward the center. Using your Copic markers, color in his jeans and the remaining firework in the box with Lapis Lazuli, his shoes with Light Suntan, and his sweater with Toner Gray No. 1.

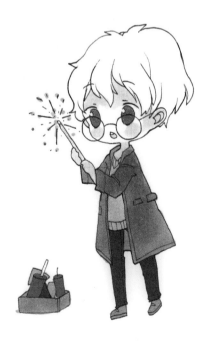

8 Now that we have the base color down, let's add some shading. Using the Powder Blue Copic marker, draw the shading in Jamie's bangs in a zig-zag formation. Using a mix of Copic Pale Cherry Pink and Skin White, blend downward in his bangs, starting from the edge of the blue shading. Use the Pale Cherry Pink to shade in his skin, from the outside in. Also dot some of this color under his eyes for blush. Using the Pale Lilac Copic marker, shade in his irises and very gently go over the coat to give the appearance of a fabric texture. Using the Crayola Polynesian Purple, add more opaque shading under the sleeves, inside the coat, and to the fireworks in the box.

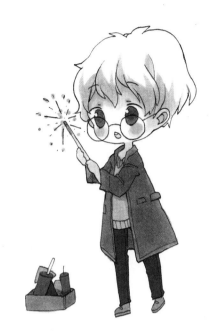

DRAW YOUR OWN!

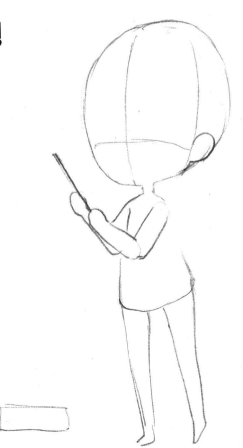

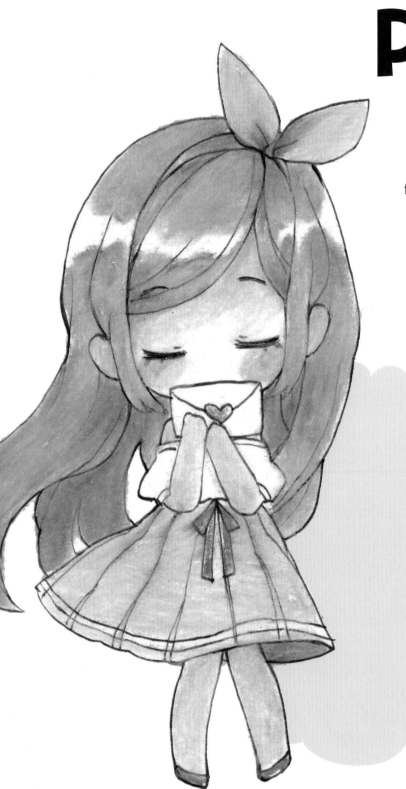

Phoebe
February

The month of February includes the celebration of Valentine's Day. Who is Phoebe confessing her affection to?

materials

- ♥ Pencil
- ♥ Eraser
- ♥ Black Sakura Pigma Micron 0.1mm fineliner
- ♥ Prismacolor colored pencils: Peach (939), Pink (929), Parma Violet (1008), Spanish Orange (1003), Poppy Red (922), White (938), Light Cerulean Blue (904)

1 Using a pencil, draw a large oval for the head and a trapezoid shape for the body— Phoebe is facing forward.

2 Draw Phoebe's arms and legs, with both arms bent upward to hold a letter and the legs slightly bent with the knees inward. Add the guidelines for the face and the neck and ears.

3 Sketch in her face—let's give Phoebe an expression of being in love, as she holds a Valentine with her eyes closed.

4 Phoebe needs some hair and clothes to complete her look! Let's give her thick, straight, long hair, swept to the side with a ribbon tied in a bow. She wears an off-the-shoulder blouse, pleated skirt with a bow, and flats. Draw a simple rectangle for the letter she holds in her hands.

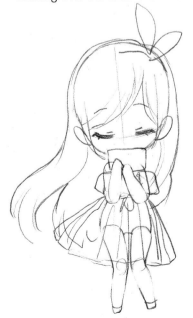

5 Our sketch is messy—clean it up with your eraser! Add more details to the love letter, including a heart sealing the envelope, along with clothing folds and seams and strands of hair.

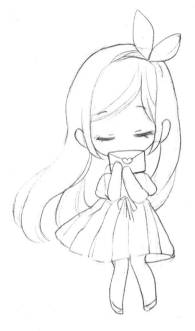

6 Using your fineliner, go over your pencil lines. Draw in the lines, making sure to vary the thickness to add more depth. When drawing the hair, press lighter toward the ends of the strands. Make sure the ink is dry before you begin erasing.

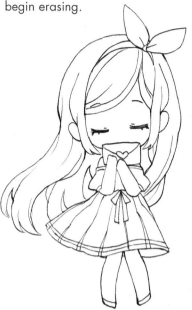

7 Let's add some base color! Use a thin, even layer of color as we will be smoothing and blending it later. Using the Peach pencil, color in Phoebe's skin, avoiding the middle of her face. Use Pink for blush under her eyes, as well as on her knees and elbows and where her hair touches her forehead. Also color in her hair with this pencil; however, when coloring her bangs, leave a band clear of color to serve as a highlight—color from the edge of the highlight, pushing your pencil outward. Fill in the underside of her hair and the edges of the highlight with Parma Violet, gently going over areas on her hair to make the color warmer. Use Spanish Orange on the ends of her hair. Finally, use Spanish Orange to color in her hair ribbon and skirt, adding Poppy Red to the skirt's pleats and ribbon, as well as her shoes. Don't forget to color in the heart on the envelope with the Pink pencil!

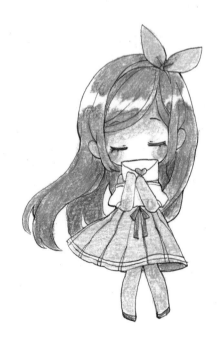

8 Now that we have the base color down, let's blend. If you prefer a traditional pencil look, skip this step; otherwise, using the White pencil, blend all the colors together. To do this, first press firmly with the pencil and go over the whole area in a "straight-line" fashion (see page 40), then press lightly going over it again in a circular motion. Try to avoid the fineliner lines; you may need to use your fineliner to go over some lines that have become too faded. Use the Light Cerulean Blue pencil to add a blue hue to the underside of Phoebe's hair, on some of the outer strands, and on the sides where the hair is tucked away with the ribbon—blend again with the White pencil if needed.

DRAW YOUR OWN!

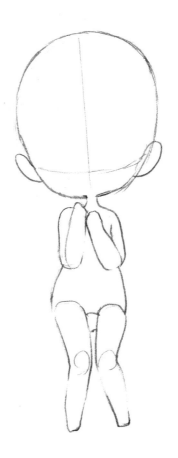

spring
march

Spring loves flowers and is attentive to each and every one she plants. Now that the cold weather is starting to subside, little budding plants may appear toward the end of this month.

materials

- Pencil
- Eraser
- Sargent Watercolor Art-Time Pan (8-color set) and accompanying brush
- Palette or flat piece of plastic (such as an old credit card or container lid)
- Cup of water
- Paper towel (for cleaning/drying the brush and wiping away/ cleaning up excess paint)

1 Using a pencil, draw a large oval for the head and a trapezoid shape for the body that slightly bends at the waist. Spring is facing to the left (well . . . *your* left and her right side).

2 Draw Spring's arms and legs, with her arms holding a watering can and her legs bent at the knees. Draw a flower to be watered! Add the guidelines for the face and the neck and ear.

3 Sketch in her face—let's give Spring a sweet expression, as she looks downward to attend to the flower.

4 Spring needs some hair and clothes to complete her look! Let's give her thick, straight, long hair with long bangs, loose tendrils, and a topknot. She wears a T-shirt, short overalls, and flats.

5 Our sketch is messy—clean it up with your eraser! Draw in the sun and a flower accessory in her hair, along with any clothing folds and seams and strands of hair.

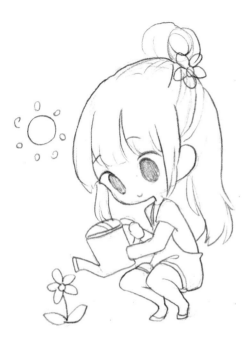

6 Using your pencil (or a waterproof colored pencil), go over your pencil lines. Draw in the lines, making sure to vary the thickness to add more depth. When drawing the hair, press lighter toward the ends of the strands. Make sure the ink is dry before you begin erasing.

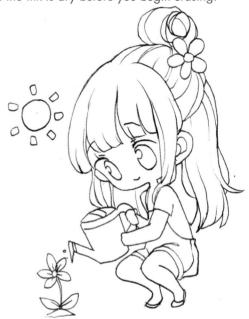

7 Let's add some base color! Remember to rinse and dry your brush every time you change colors. Mix a dab of orange paint with a tiny dot of yellow. Dilute with enough water so it creates a translucent, pale skin tone and apply an even layer all over Spring's exposed skin avoiding the center of her face, hands, and knees—these areas are where the main highlights will be. Next, use a dab of yellow mixed with water on the sun and the center of the flower in her hair. Make sure it's slightly opaquer than the color we mixed for her skin. Before this yellow dries, add some green into it until it is a yellow-green, and color in her irises, shoes, and the flower leaves. To get a gray-blue color, individually mix the black and blue paints with a lot of water and then apply them to the watering can and overall shorts, respectively. Finally, add a dab of brown into the skin color you mixed and color in her hair.

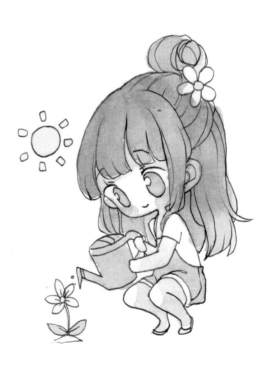

8 Now that we have the base color down, let's add some shading. Dilute a dab of red with water and use it to shade in her shirt and color in the flower petals. Also use this color to shade her skin, beginning at the edges of the highlights on her face, hands, and knees. On your palette, darken this red by adding a bit more of the red paint and a small dab of orange, and use this to color Spring's cheeks. Add some brown to this color and add shading to her hair (as shown), leaving the top area highlighted because it is facing the sun. Mix a bit of red into purple and dilute with water until it is about the same opacity as the previous color we used to shade her hair. Use this to shade in the flower petals, irises (don't forget the pupil!), watering can, and overall shorts. Also use this color to add additional shading to the underside of her hair and where the hair folds over itself.

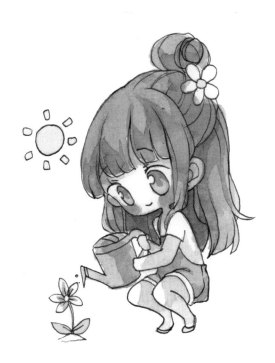

DRAW YOUR OWN!

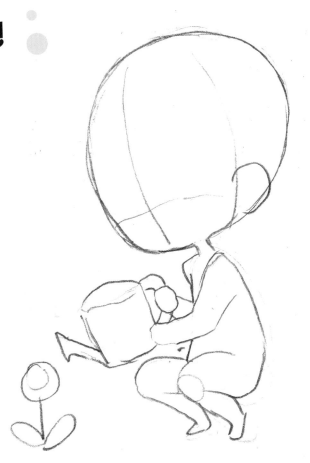

Abel
April

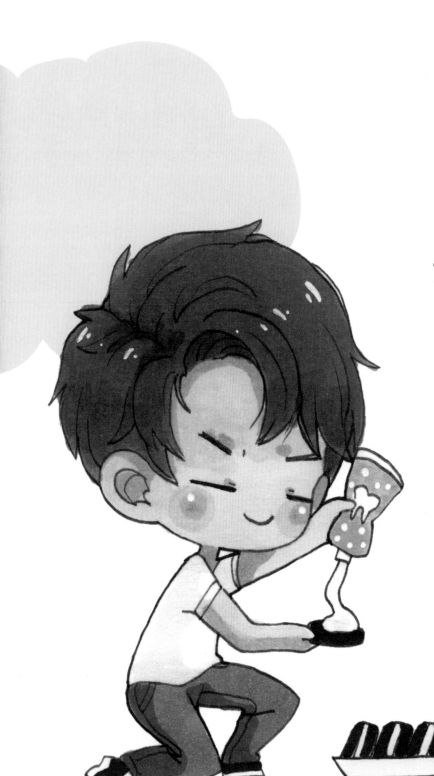

It's April Fools' Day and Abel is having some fun. It's the one day of the year where practical jokes are customary; however, remember that pulling pranks is about making everyone laugh, not just you.

materials

- ♥ Pencil
- ♥ Eraser
- ♥ Black Sakura Pigma Micron 0.1mm fineliner
- ♥ Touchnew markers: 25, 94, 70, 143, 140, 144, CG5
- ♥ White Uni-ball Signo gel pen

1 Using a pencil, draw a large oval for the head and a trapezoid shape for the body that slightly bends at the waist. Abel is facing to the right (well . . . *your* right and his left side).

2 Draw Abel's arms and legs, with his right arm holding a cookie bottom and his left arm squeezing a tube of toothpaste. His legs are bent at the knees as he kneels with his right leg with the bottom of the foot facing up. Draw the outline of a simple rectangle that will be a box that holds cookie sandwiches. Add the guidelines for the face and the neck and ear.

3 Sketch in his face—let's give Abel a mischievous expression, as he carries out his prank. Give the tube of toothpaste more detail with an image of a tooth and a line at the base of the tube.

4 Abel needs some hair and clothes to complete his look! Let's give him thick, straight hair with a side part. He wears a T-shirt, jeans, and sneakers.

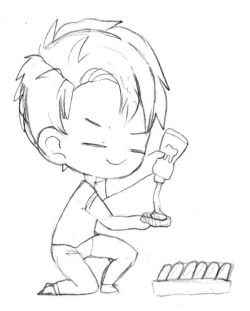

5 Our sketch is messy—clean it up with your eraser! Add more details to the cookie box and sandwich cookies, along with clothing folds and seams and strands of hair.

6 Using your fineliner, go over your pencil lines. Draw in the lines, making sure to vary the thickness to add more depth. When drawing the hair, press lighter toward the ends of the strands. Make sure the ink is dry before you begin erasing.

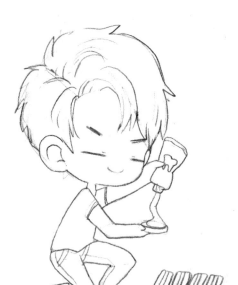

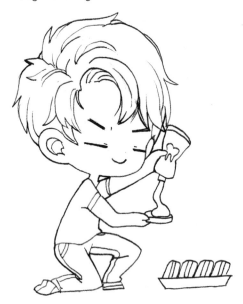

7 Let's add some base color! Color in Abel's shoes and the cookies with your black fineliner, leaving the middle of each cookie and the soles of his shoes white. Using the Touchnew 25 marker, color in his skin. Add an extra layer of this color around his forehead. Color in his hair with 94, his jeans with 70, and the toothpaste tube with 143. Leave the toothpaste, toothpaste-tube design, and his shirt white.

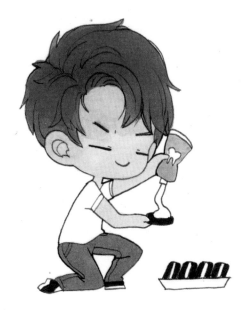

8 Now that we have the base color down, let's add some shading. Using the Touchnew 140 marker, add shading along Abel's hairline, on his neck and arms, inside his ears, and above his eyelids and eyebrows. Add blush with this color to his cheeks—slightly blend this in a circular motion with 25. Using 94, go over his hair again, starting at the part in his hair and shading lighter as you move outward toward the edge of his head. If desired, add shading to the bottom parts of his hair too. Using 144, press lightly and shade in his shirt and the bottom of the cookie plate. Using CG5, add shading to the back of his jeans (as shown). Use your white gel pen to add highlights to Abel's cheeks and hair, and for the dotted design on the toothpaste tube.

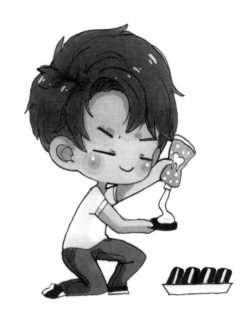

DRAW YOUR OWN!

mother
may

May is the month for celebrating Mother's Day. This is what I imagine Mother Nature might look like it if she was a human.

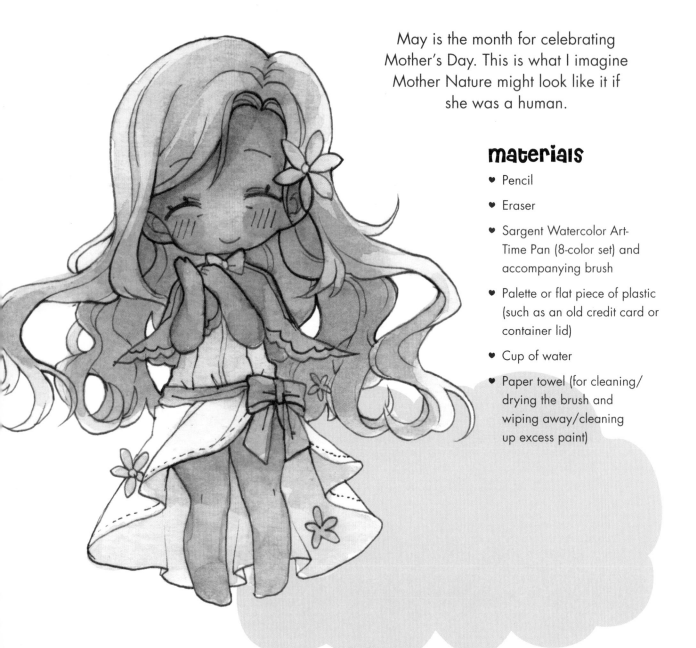

materials

- ♥ Pencil
- ♥ Eraser
- ♥ Sargent Watercolor Art-Time Pan (8-color set) and accompanying brush
- ♥ Palette or flat piece of plastic (such as an old credit card or container lid)
- ♥ Cup of water
- ♥ Paper towel (for cleaning/drying the brush and wiping away/cleaning up excess paint)

1 Using a pencil, draw a large oval for the head and a trapezoid shape for the body. Mother is facing forward.

2 Draw Mother's arms and legs, with both arms bent up toward her face and the legs slightly bent with the knees inward. Add the guidelines for the face and the neck and ears.

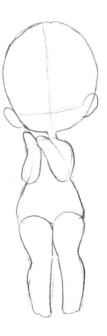

3 Sketch in her face—let's give Mother an expression of smiling peacefully, as she enjoys nurturing everything on this great planet of ours.

4 Mother needs some hair and clothes to complete her look! Let's give her long, wavy hair with a side part, sideswept bangs, and a flower accessory. She wears a flowy dress that is shorter in the front and longer in the back, along with a scalloped capelet and bows at her waist and neck.

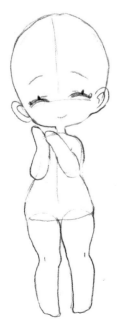

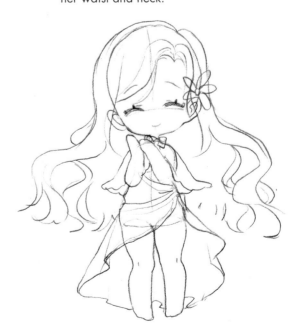

 5 Our sketch is messy—clean it up with your eraser! Add flowers to her dress and hair. Dot two spots below the inner corners of her eyes to make her look older.

6 Using your pencil (or a waterproof colored pencil), go over your pencil lines. Draw in the lines, making sure to vary the thickness to add more depth. When drawing the hair, press lighter toward the ends of the strands. Make sure the ink is dry before you begin erasing.

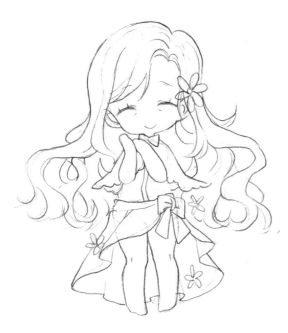

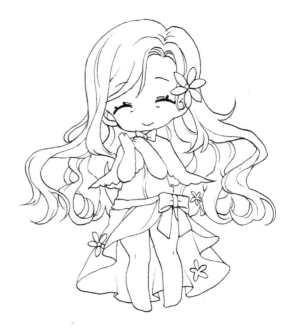

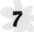 **7** Let's add some base color! Remember to rinse and dry your brush every time you change colors. Dilute some brown paint with water and color in all areas of Mother's skin. Wait until it dries, and then go over her hairline area, side of her face, and thighs once again. Dilute some yellow with water and add a tiny dot of black; dilute the mixture with more water. Color in her hair and the inside of the bottom of her skirt. Add a dab of the brown we used for her skin and go over her hair again, avoiding the outer sides and tips. Mix equal amounts of red and purple, dilute with lots of water, and color in her capelet. Finally, mix together a dab of blue and a tiny dot of green, dilute, and color in the flowers and bows. Go over the capelet and the inside of her skirt with this color to add an overall blue glow.

8 Now that we have the base color down, let's add some shading. Continuing with the same blue color as in the previous step, shade in the bows (as shown). Dilute this color further and add it to the inside of the top of her skirt. Add a bit of red and brown to the brown we used for Mother's skin in the previous step and shade in the areas of her skin that are touching her hair and clothes. Dilute this color once more and add shading to her hair, starting from the back and working toward the front. Make sure your brushstrokes follow the direction her hair is flowing! Using the same blue for shading the bows, dab it onto some of the white of the dress, capelet, and underside of the hair (only at the bottom).

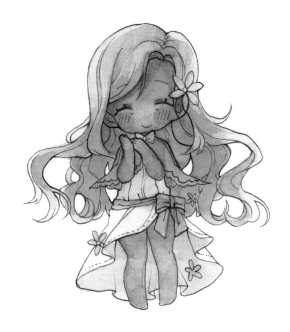

DRAW YOUR OWN!

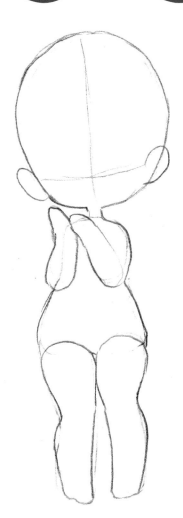

Father
June

June is the month for celebrating Father's Day. Father is making pancakes for himself to celebrate, but why aren't his children making them for him?!

materials

- Pencil
- Eraser
- Sargent Watercolor Art-Time Pan (8-color set) and accompanying brush
- Palette or flat piece of plastic (such as an old credit card or container lid)
- Cup of water
- Paper towel (for cleaning/drying the brush and wiping away/cleaning up excess paint)
- White Uni-ball Signo gel pen

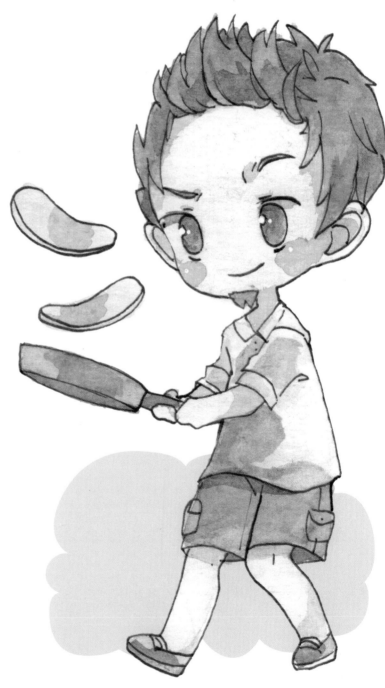

1 Using a pencil, draw a large oval for the head and a trapezoid shape for the body that is slightly bent at the waist. Father is facing to the left (well . . . *your* left and his right side).

2 Draw Father's arms and legs, with both arms holding a skillet, the right leg kicked out diagonally, and the left leg bent at the knee. Add the guidelines for the face and the neck and ears.

3 Sketch in his face—let's give Father a look of concentration, as he focuses on flipping some pancakes. Don't forget to draw the pancakes!

4 Father needs some hair and clothes to complete his look! Let's give him short hair that is styled upward. He also has a goatee! He wears a polo shirt, cargo shorts, and sneakers.

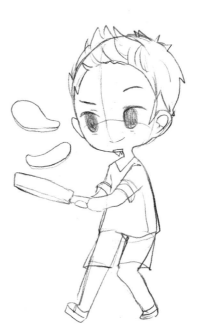

Our sketch is messy—clean it up with your eraser! Add more details, such as clothing folds, seams, and pockets, as well as strands of hair.

Using your pencil (or a waterproof colored pencil), go over your lines. Draw in the lines, making sure to vary the thickness to add more depth. When drawing the hair, press lighter toward the ends of the strands. Make sure the ink is dry before you begin erasing.

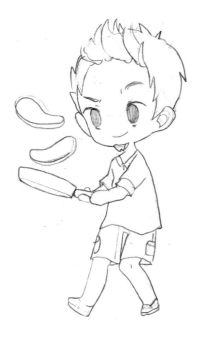

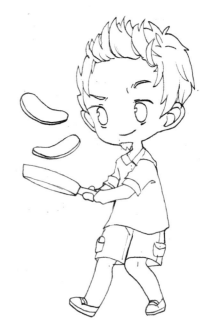

Let's add some base color! Remember to rinse and dry your brush every time you change colors. The following paint colors and mixes should be diluted with large amounts of water before being applied, in order to ensure the base colors are light so the end result has more contrast when dramatic shading is added. For Father's hair, goatee, and shoes, use the brown paint. Use an equal mix of yellow and orange for his skin, going over the area underneath his eyebrows a second time. Add a dab of the diluted brown used for the hair to green and apply this color to the shorts and irises. Add some more yellow to the skin mixture and color in the pancakes. Paint a blue gradient on the front of his shirt to serve as a shadow from the pan. For the pan, dilute black to make gray. Also, use that blue to make a gradient in his eyes.

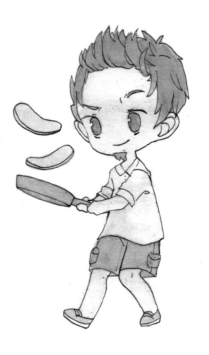

8 Now that we have the base color down, let's add some shading. When you mix the colors for the shading, make sure there's slightly more pigment in them than the base colors. The color combinations are as follows: a mix of more brown than red for Father's hair and shoes; an equal mix of red and orange for his face and the pancakes; an equal mix of purple and brown for his shorts and eyes; and purple for his shirt. When shading the hair, start from the bottom moving up, making sure the tips of the shading look "spiky" to emphasize the texture of the hair. For his shirt, make sure the shading starts with the "shadow" from the pan. Shade the pan with gray, and add hints of blue paint to areas of the hair that have no shading. Finally, add highlights to his eyes and cheeks with your gel pen.

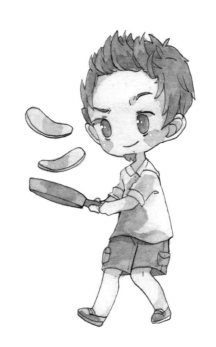

DRAW YOUR OWN!

Jules
July

Get out the fireworks to celebrate, whether it's Bastille Day in France, Independence Day in the United States, or Canada Day in Canada.

materials

- ♥ Pencil
- ♥ Eraser
- ♥ Black Sakura Pigma Micron 0.1mm fineliner
- ♥ Touchnew markers: 36, 18, 14, 163, 68, 144, 48, BG1
- ♥ White Uni-ball Signo gel pen

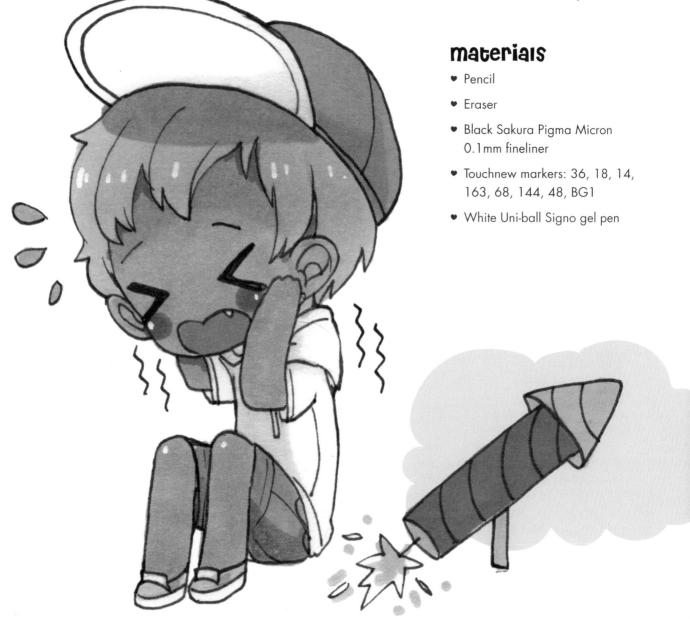

1 Using a pencil, draw a large oval for the head and a trapezoid shape for the body that is slightly bent at the waist. Jules is facing to the left (well . . . *your* left and his right side).

2 Draw Jules' arms and legs, with both arms bent upward to cover his ears and the legs bent at the knees in a sitting position. Add the guidelines for the face and the neck and ears. Draw a rectangle at a diagonal on a thin stick for the outline of the firecracker.

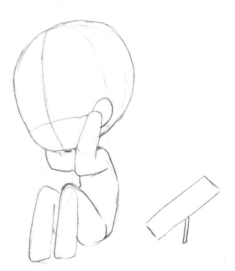

3 Sketch in his face—let's give Jules a frightened expression, as he anticipates the loud launch of the firecracker. Add some drops to highlight his shocked emotion. Also give the firecracker more detail.

4 Jules needs some hair and clothes to complete his look! Let's give him thick, straight hair that peeks out from under a baseball cap with the brim flipped up. He wears a short-sleeved hoodie, jean shorts, and sneakers.

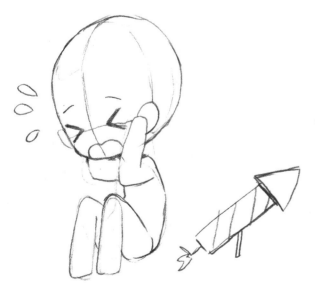

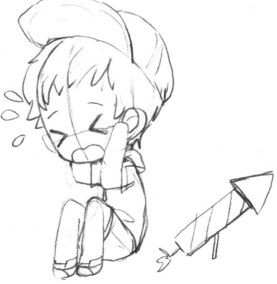

 5 Our sketch is messy—clean it up with your eraser! Add more details, such as clothing folds and seams and a tooth.

 6 Using your fineliner, go over your pencil lines. Draw in the lines, making sure to vary the thickness to add more depth. When drawing the hair, press lighter toward the ends of the strands. Make sure the ink is dry before you begin erasing.

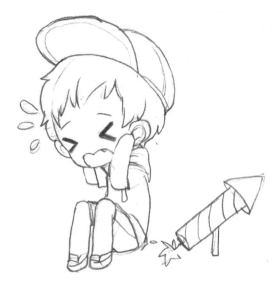

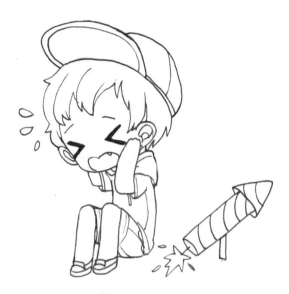

7 Let's add some base color! The colors for this illustration should be opaque and flat, so if you find that your application is streaky, you may need to go over them a few times until you get solid colors. Use the Touchnew 36 marker for Jules' skin and the tip, tail, spark, and stand of the firework. Color the inside of his mouth with 18, making sure to avoid the tooth. Using 14, dot in blush underneath the outer corners of his eyes and color in the body of the firework. Use 163 for his hair and shoes, and 68 for the top of his cap. Finally, use BG1 for the sweat drops and jean shorts.

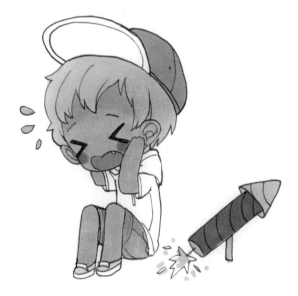

8 Now that we have the base color down, let's add some shading; however, if you prefer the flat color, skip this step. As thinly as you can, use the Touchnew 14 marker to add shading along Jules' hairline, creating a contrast between his hair and skin colors. Using 48, shade a semicircle on his hair, creating a shadow that follows the brim of his cap. Use 144 to add a gradient at the base of his cap and go over his shorts a few times with this marker to get a darker shade. Use the Blue Grey Marker to add a shadow to the front of his shirt. Finally, dot highlights on Jules' hair and cheeks with the white gel pen and add squiggly lines around him with your fineliner.

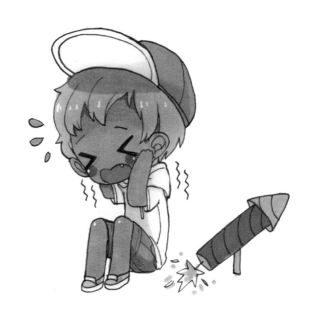

DRAW YOUR OWN!

Audrey
AUGUST

Summer's over, so it's back-to-school time! However, that doesn't mean everyone will go happily, as demonstrated here by Audrey.

materials

- ♥ Pencil
- ♥ Eraser
- ♥ Black Sakura Pigma Micron 0.1mm fineliner
- ♥ Prismacolor colored pencils: Peach (939), Pink (929), Apple Green (912), Spanish Orange (1003), True Blue (903), White (938), Parma Violet (1008)

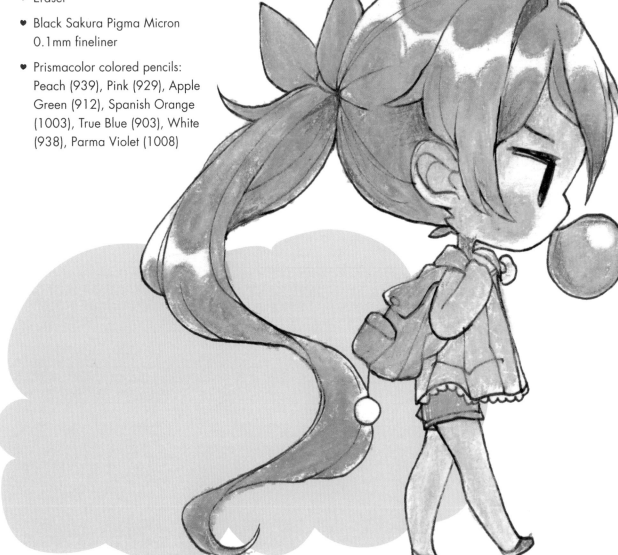

1 Using a pencil, draw a large oval for the head and a trapezoid shape for the body. Audrey is facing to the right (well . . . *your* right and her left side).

2 Draw Audrey's arms and legs, with both arms bent upward to hold on to her backpack straps and the legs in a walking position. Add the guidelines for the face and the neck and ear. Add a bubblegum bubble at her mouth and the outline of a backpack.

3 Sketch in her face—let's give Audrey an annoyed expression, as she clearly does not want to return to class. Define the backpack more.

4 Audrey needs some hair and clothes to complete her look! Let's give her long bangs with loose tendrils and a super-long ponytail fastened with a bow. She wears a sleeveless A-line blouse with a ruffled hem, jean shorts, and flats. Add more detail to her backpack, including a charm hanging off it.

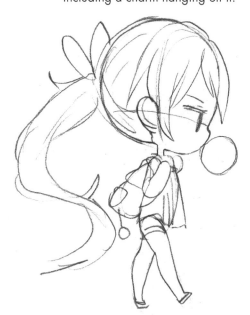

Our sketch is messy—clean it up with your eraser! Add more details, such as clothing folds and seams and strands of hair.

Using your fineliner, go over your pencil lines. Draw in the lines, making sure to vary the thickness to add more depth. When drawing the hair, press lighter toward the ends of the strands. Make sure the ink is dry before you begin erasing.

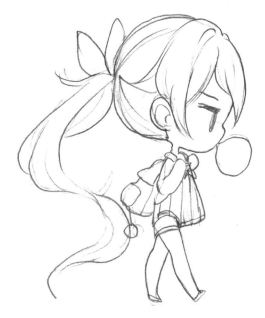

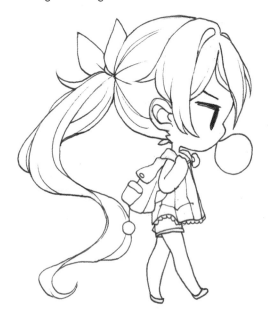

7

Let's add some base color! Use the Peach pencil for Audrey's skin, avoiding the white of her eye and her nose area. Use the Pink pencil to add blush to her cheeks and to color in her shoes, backpack, and bubble (leaving a white highlight on the top of the bubble). Alternating among the Apple Green, Spanish Orange, and True Blue pencils, lightly add in the color for her hair. Make sure to leave highlights on the top of her head and on the ponytail (as shown), preferably in a jagged pattern. Add a bit of Apple Green to the top of the bubble and some Pink to the tips of of the loose tendrils touching her face. Color in the hair bow and jean shorts with the True Blue pencil and her blouse with the Spanish Orange pencil.

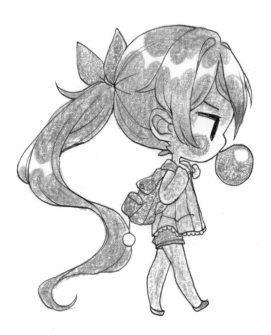

8 Now that we have the base color down, let's blend. If you prefer a traditional pencil look, skip this step; otherwise, using the White pencil, blend all the colors together. To do this, first press firmly with the pencil and go over the whole area in a "staright-line" fashion (see page 40), then press lightly going over it again in a circular motion. Try to avoid the fineliner lines; you may need to use your fineliner to go over some lines that have become too faded. Use the Parma Violet pencil to add a purple hue to the underside of Audrey's hair, where it folds over itself—blend again with the White pencil if needed.

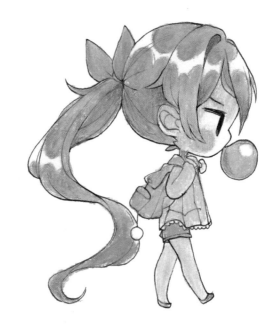

DRAW YOUR OWN!

stefan
september

Autumn has finally arrived! Stefan likes to rake up all the leaves and then undo his hard work by jumping into the pile. Whee!

materials

- ♥ Pencil
- ♥ Eraser
- ♥ Black Sakura Pigma Micron 0.1mm fineliner
- ♥ Copic markers: Skin White (E00), Pink (RV11), Hazelnut (E23)
- ♥ Touchnew markers: 16, WG3, 35
- ♥ Crayola Signature Blending markers: Wisteria, Slate
- ♥ White Uni-ball Signo gel pen

1 Using a pencil, draw a large oval for the head and a trapezoid shape for the body. Stefan is facing forward.

2 Draw Stefan's arms, with both of them straight and raised up to the sides of the head. Add the guidelines for the face and the neck and ears. From the base of the body, add an outline of a large pile of leaves, along with leaves on the ground and in the air around him.

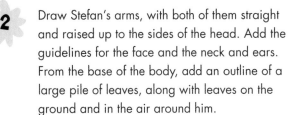

3 Sketch in his face—let's give Stefan an expression of exhilaration, as he plays in the pile of leaves. Add more definition to the leaves in the large pile.

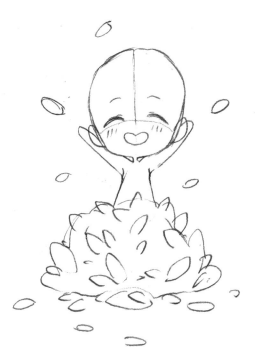

4 Stefan needs some hair and clothes to complete her look! Let's give him thick, straight hair with a cowlick sticking up at the crown of the head. He wears a cardigan with a T-shirt underneath.

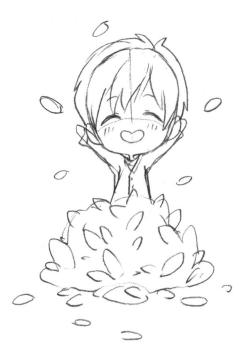

Our sketch is messy—clean it up with your eraser! Add more details, such as clothing folds and seams and strands of hair.

Using your fineliner, go over your pencil lines. Draw in the lines, making sure to vary the thickness to add more depth. When drawing the hair, press lighter toward the ends of the strands. Make sure the ink is dry before you begin erasing.

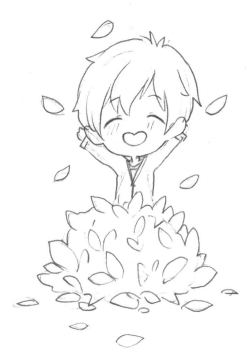

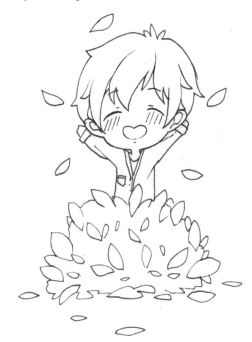

Let's add some base color! Using the Skin White Copic marker, color in Stefan's skin starting from the top moving down, focusing on his forehead, ears, cheeks, inside of his mouth, neck, and hands. Using the Touchnew markers, color in his hair with 16 and his sweater with WG3. For the leaves, use 35; color in one layer and then go over it a second time, making the ink thicker in some areas and thinner in others.

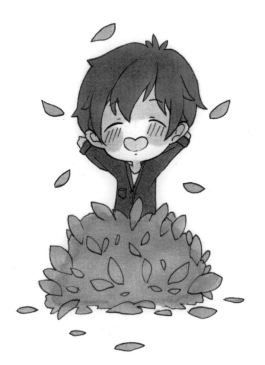

8 Now that we have the base color down, let's add some shading. Using the Wisteria Crayola marker, add shading to Stefan's hair, mainly focusing on the bangs and where the hair folds over itself. Using the Pink Copic marker, shade in the skin around his hairline, his cheeks, the insides of his ears, the inside of his mouth, his neck, and his hands. Use the Slate Crayola marker to add shading to his sweater (as shown). For adding shade to the leaves, use the Copic Hazelnut marker. It is easiest to focus on one small area at a time and fill in any cracks between the sections; of course, you will need to ensure that the shading follows the shapes of the leaves. Finally, use your white gel pen to add highlights to his hair.

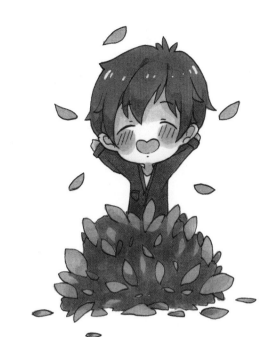

DRAW YOUR OWN!

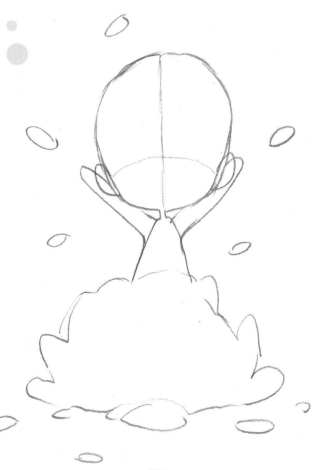

Oliver
october

Trick-or-treat! It's Halloween. Hardly anyone ever gives out tricks anymore, so Oliver is collecting as many treats as he can.

materials

- ♥ Pencil
- ♥ Eraser
- ♥ Black Sakura Pigma Micron 0.1mm fineliner
- ♥ Touchnew markers: 29, WG9, 13, 23, 35
- ♥ Crayola Signature Blending markers: Slate, Violet, Wisteria
- ♥ Copic markers: Toner Gray No. 1 (T1), Light Suntan (E13)
- ♥ White Uni-ball Signo gel pen

 1 Using a pencil, draw a large oval for the head and a trapezoid shape for the body. Oliver is facing forward with his head slightly tilted to the right (well . . . *your* right and his left side).

 2 Draw Oliver's arms and legs, with the arms bent upward to hold a jack-o'-lantern for trick-or-treating and the legs in a straight position, pointing slightly inward. Add the guidelines for the face and the neck and ears.

3 Sketch in his face—let's give Oliver a look of uncertainty, as he's out a little too late alone. Draw the jack-o'-lantern for collecting candy and the bats hanging down.

4 Oliver needs some hair and clothes to complete his look! Let's give him thick, straight hair that is slicked back. He wears a Halloween costume, which is of Count Dracula. Scatter some loose candy on the ground around him.

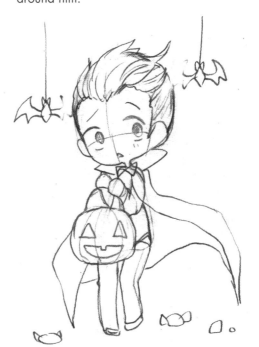

5 Our sketch is messy—clean it up with your eraser! Add more details, such as clothing folds and seams and strands of hair.

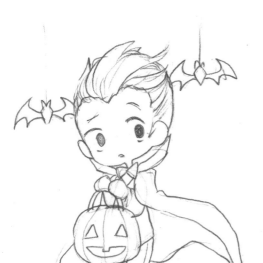

6 Using your fineliner, go over your pencil lines. Draw in the lines, making sure to vary the thickness to add more depth. When drawing the hair, press lighter toward the ends of the strands. Make sure the ink is dry before you begin erasing.

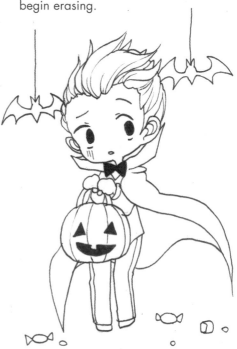

7 Let's add some base color! Apply the layers of color as flat and opaque as possible. Using the Touchnew markers, color Oliver's skin with 29, avoiding the whites of his eyes; color his cape, bow tie, and pants with WG9; color the inside of the cape and shoes with 13; and color the jack-o'-lantern with 23. Use the Slate Crayola marker for the bats and Crayola Violet for his vest. Use any combination of colors for the candies scattered on the ground.

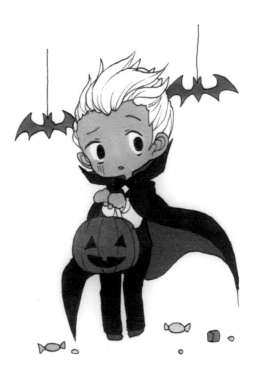

8 Now that we have the base color down, let's add some shading. Use the Toner Gray No. 1 Copic marker to add shading to Oliver's hair, starting from the hairline moving upward. Blend some the Touchnew 29 into the Copic Toner Gray No. 1 in the hair and use the same colors on the white shirt. Use the Light Suntan Copic marker to add shading along his hairline, neck, and the insides of the ears. Lightly blend in some of the Touchnew 35 with the orange of the jack-o'-lantern, focusing on the top left—this adds a slight tone variation while still maintaining the "flat" look. Use Crayola Wisteria to shade in the red of his cape, but leave a small area highlighted (as shown). Finally, use the white gel pen to outline the bow tie and seams of his pants and add shine to his eyes.

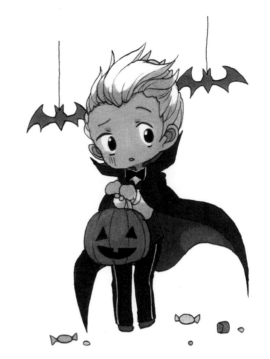

DRAW YOUR OWN!

ember
november

It's been getting colder and colder, so make sure to dress warmly! Ember knows what to do, as she snuggles in a blanket with a cup of tea.

materials

- ♥ Pencil
- ♥ Eraser
- ♥ Black Sakura Pigma Micron 0.1mm fineliner
- ♥ Copic markers: Skin White (E00), Barley Beige (E11), Pink (RV11), Mint Green (BG13), Toner Gray No. 1 (T1), Powder Blue (B41), Light Suntan (E13), Pale Lilac (V12)

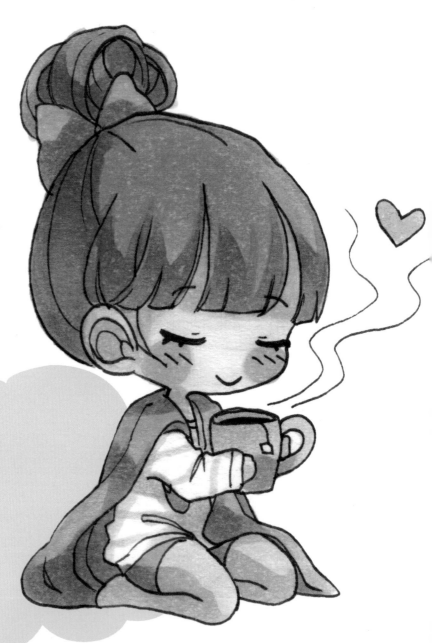

1 Using a pencil, draw a large oval for the head and a trapezoid shape for the body that is slightly bent near the chest. Ember is facing to the right (well . . . *your* right and her left side).

2 Draw Ember's arms and legs, with the arms bent up to hold a mug of tea and the legs bent underneath her. Add the guidelines for the face and the neck and ear.

3 Sketch in her face—let's give Ember a look of contentment, as she is feeling quite cozy. Add more detail to the mug, including steam and the tea-bag string, and draw the outline of the blanket around her.

4 Ember needs some hair and clothes to complete her look! Let's give her thick, straight hair with blunt bangs. Her hair is tied up in a messy topknot with a bow. She wears cozy pajamas, which are a long-sleeve sweatshirt and shorts.

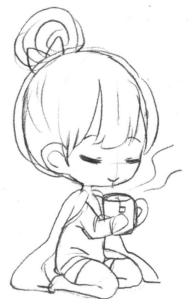

5 Our sketch is messy—clean it up with your eraser! Add even more steam coming off the mug, along with clothing folds and seams and strands of hair.

6 Using your fineliner, go over your pencil lines. Draw in the lines, making sure to vary the thickness to add more depth. When drawing the hair, press lighter toward the ends of the strands. Make sure the ink is dry before you begin erasing.

7 Let's add some base color! Using the Skin White marker, color in Ember's skin, avoiding the middle of her face. Use Barley Beige on her hair; Pink on her blanket, hair bow, and the heart; Mint Green on her shorts; Toner Gray No. 1 on the mug; and Powder Blue for the stripes on her shirt.

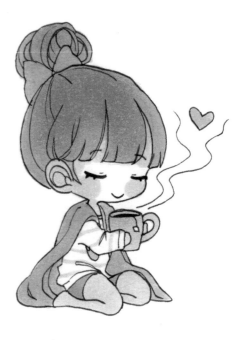

8 Now that we have the base color down, let's add some shading. To shade Ember's hair, use Light Suntan and start from the top where you want the edge of the shading to be and outline it in sharp zig-zags. Now, starting from the zig-zag line you drew, push and pull your marker downward so there is no chance of going over the lines. At the edges of the shading, gently blend in a tint of Pale Lilac. Use Pink to add shading to her cheeks, along her hairline, and her legs, avoiding the tops of them. Use Pale Lilac to add shading to her shorts, making sure that this shading lines up with the shading on her legs (as shown). Also use Pale Lilac to shade in her hair bow, mug, and blanket, applying more pressure where the fabric is folded or dented inward. Use Powder Blue to add a blue glow to the inside of the blanket and top of the blanket, where her face meets her shoulder— and apply this same method to the mug. Finally, use Toner Gray No. 1 to add shading to her sweatshirt (focus on the area where the blanket covers it).

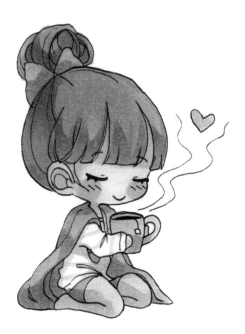

DRAW YOUR OWN!

Desiree
December

Though winter has arrived, Desiree can't resist playing in the snow and hugging cute snowmen, even grumpy-looking ones!

materials

- ♥ Pencil
- ♥ Eraser
- ♥ Black Sakura Pigma Micron 0.1mm fineliner
- ♥ Prismacolor colored pencils: Pink (929), Mulberry (995), Parma Violet (1008), Peach (939), Poppy Red (922), Spanish Orange (1003), Orange (918), Goldenrod (1034), Apple Green (912), Light Cerulean Blue (904), White (938), True Blue (903)

1 Using a pencil, draw a large oval for the head and a trapezoid shape for the body. Desiree is facing to the left (well . . . *your* left and her right side).

2 Draw Desiree's arms, with the arms outstretched in front of her and the right leg kicked up behind her. Add the guidelines for the face and the neck and ear.

3 Sketch in her face—let's give Desiree a blissful expression, as she moves in to hug a snowman. Draw the snowman to the left of her so part of his head is between her arms. Add details to the snowman, including its grumpy face, stick arms, and buttons. Don't forget the carrot sticking out the top of its head!

4 Desiree needs some hair and clothes to complete her look! Let's give her long bangs with loose tendrils and space buns. She wears a dress with tights underneath a coat, along with a scarf and flats.

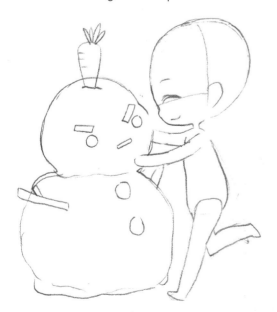

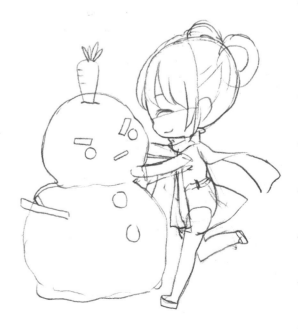

5 Our sketch is messy—clean it up with your eraser! Add a heart between Desiree and the snowman, along with clothing folds and seams and strands of hair.

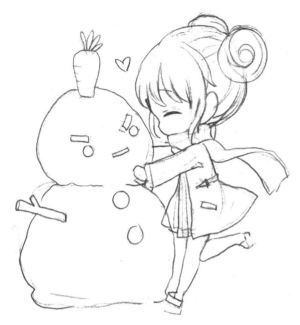

6 Using your fineliner, go over your pencil lines. Draw in the lines, making sure to vary the thickness to add more depth. When drawing the hair, press lighter toward the ends of the strands. Make sure the ink is dry before you begin erasing.

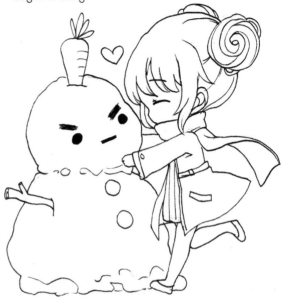

7 Let's add some base color! Use your fineliner or a black marker to fill in her tights. For this illustration, the pigment needs to be heavier, so apply the base colors as smooth and even as possible. Color in Desiree's hair with Pink, using Mulberry at the tips of the loose tendrils and the bottom of the left space bun, Parma Violet on the strands of hair, and Peach on the top of her head and tips of her bangs. Use Peach for her skin, making the color heavier along her bangs. Add a blush to her face with Pink. Color in the scarf, shoes, snowman's buttons, and heart with Poppy Red, using Parma Violet for the underside of the scarf. Evenly blend together Spanish Orange, Orange, and Goldenrod for the coat, using more Goldenrod on her right sleeve and the snowman's stick arm. Evenly blend together Spanish Orange and Orange for the carrot, using Apple Green for the stem. Color in her dress and parts of the snowman, following its curves, with Light Cerulean Blue, Parma Violet, Pink, and Goldenrod (as shown).

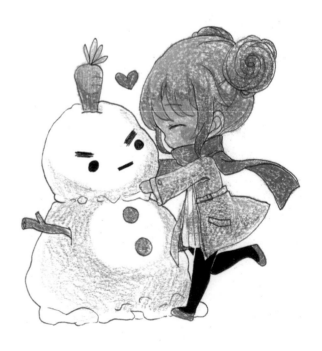

8 Now that we have the base color down, let's blend. If you prefer a traditional pencil look, skip this step; otherwise, using the White pencil, blend all the colors together. To do this, first press firmly with the pencil and go over the whole area in a "straight-lines" fashion (see page 40), then press lightly going over it again in a heavily circular motion. If you applied enough base color, you should not be seeing any streaks; if you are seeing streaks, add more of the base color(s) to those sections. You may need to use your fineliner to go over some lines that have become too faded. Use True Blue to add a blue hue to the warm colors (pinks) and Parma Violet to darken any areas that have become too light.

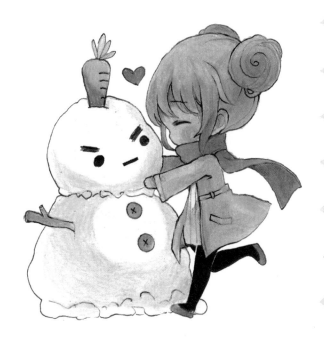

DRAW YOUR OWN!

chibi Beasties

The chibis in this section are anthropomorphic, or anthro for short, which means they are nonhuman creatures that have humanoid features. Have fun learning how to draw these chibis with bodies and builds of humans, along with their nonhuman features, such as animal ears and tails, insect wings and antennas, and more!

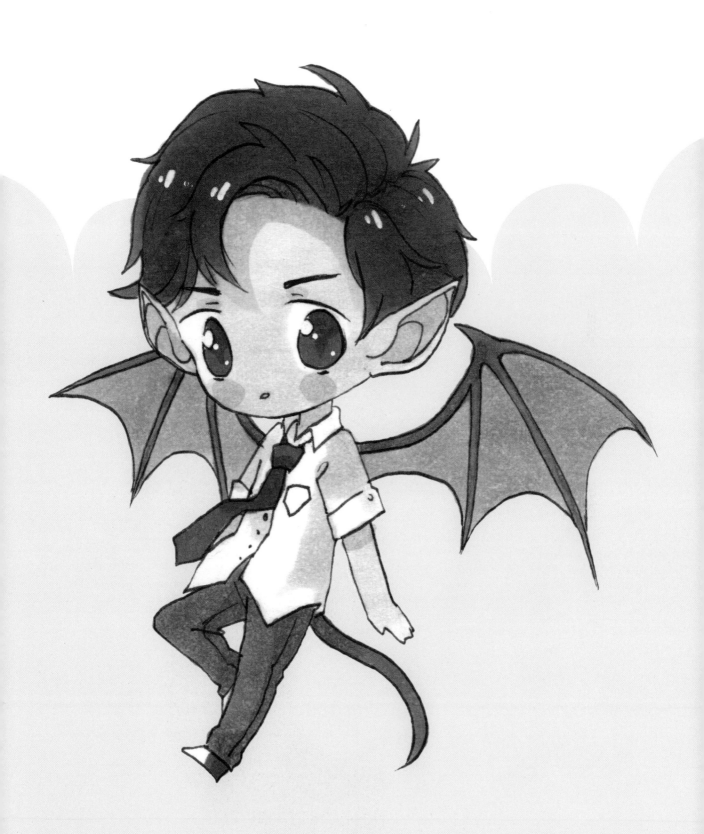

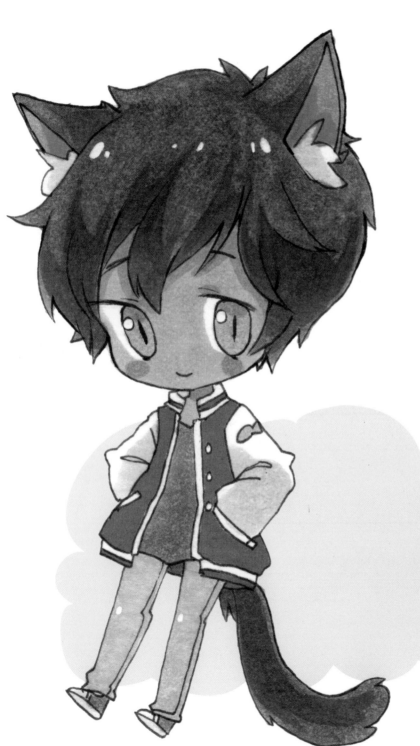

Kit

Cats are cool, right? They are essentially tiny tigers that walk around your home silently watching you, wreaking havoc, or cuddling with you . . . depending on the cat.

materials

- ♥ Pencil
- ♥ Eraser
- ♥ Black Sakura Pigma Micron 0.1mm fineliner
- ♥ Copic markers: Barley Beige (E11), Toner Gray No. 1 (T1)
- ♥ Bic Marking markers: Summer Melon, Cloud Nine, Sunset Orange, Oceanview Blue, Peach Parfait
- ♥ Crayola Signature Blending markers: Slate, Bubblegum
- ♥ White Uni-ball Signo gel pen

1 Using a pencil, draw a large oval for the head and a trapezoid shape for the body that bends a little bit up by the chest—Kit is facing to the left (well . . . *your* left and his right side).

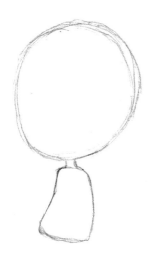

2 Wouldn't it be cool if Kit had his hands in his pockets? Diagonally draw the legs, as Kit likes to lean. Add the guidelines for the face and the neck.

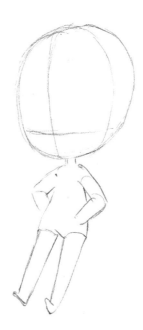

3 Draw the catlike ears and tail. When drawing tails, make sure they branch out from the spinal cord. Sketch in his face—let's give Kit a cool, smiling expression, as he looks at you.

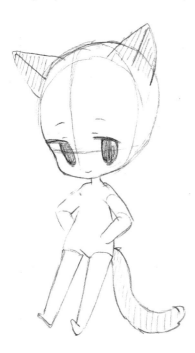

4 Kit needs some hair and clothes to complete his look! Let's give him thick, straight hair. He wears a varsity jacket with a fish patch on the sleeve, T-shirt, jeans, and sneakers.

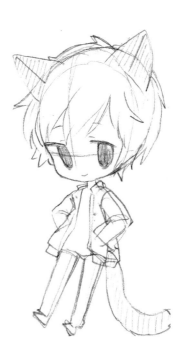

5 Our sketch is messy—clean it up with your eraser! Now add tufts of fur inside Kit's ears, along with clothing folds and seams and strands of hair.

6 Using your fineliner, go over your pencil lines. Draw in the lines, making sure to vary the thickness to add more depth. When drawing the hair, press lighter toward the ends of the strands. Make sure the ink is dry before you begin erasing the pencil lines.

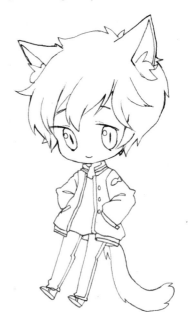

7 Let's add some base color! Using your Barley Beige Copic marker, fill in his face and neck, avoiding the whites of the eyes. Use the Summer Melon Bic marker to fill in his irises, as well as the fish patch on the jacket sleeve. Using the Bic markers, color in his hair, outer ears, tail, and shoes with Cloud Nine, his jacket with Sunset Orange, his jeans with Oceanview Blue, and the insides of his ears with Peach Parfait, leaving the tufts of fur inside the ears white.

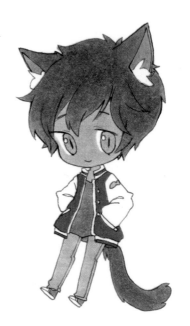

8 Now that we have the base color down, let's add some shading. Using your Slate Crayola marker, shade in Kit's hair and tail, starting with strokes from the bottom moving upward—you want your shade to be thicker on the bottom and thinner toward the top. Use the Bubblegum Crayola marker to shade in the insides of Kit's ears, along his hairline, and on the overlap of his eyelids. Add some blush too. Using your Toner Gray No. 1 Copic marker, lightly add shading to the white areas of the ears and jacket sleeves. Finally, use the white gel pen to add some highlights to Kit's hair and jeans.

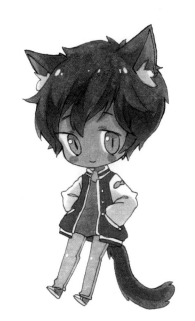

DRAW YOUR OWN!

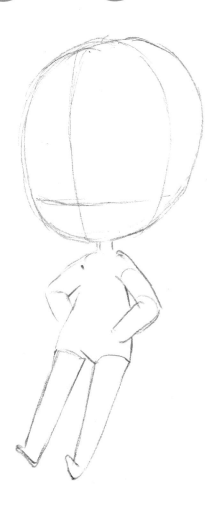

goldie

Dogs are our loyal companions and no matter what they do, they are always adorable. It would be great if they would stop digging up yards looking for nonexistent bones though . . .

materials

- ♥ Pencil
- ♥ Eraser
- ♥ Black Sakura Pigma Micron 0.1mm fineliner
- ♥ Prismacolor colored pencils: Spanish Orange (1003), Sienna Brown (945), Peach (939), Apple Green (912), True Blue (903), Pink (929), Parma Violet (1008), White (938)

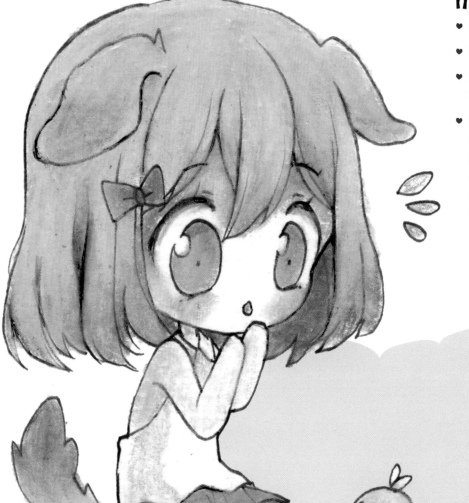

1 Using a pencil, draw a large oval for the head and a trapezoid shape for the body that slightly bends at the waist. Goldie is facing to the right (well . . . *your* right and her left side).

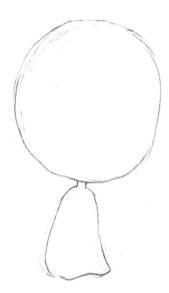

2 Draw Goldie's arms and legs, with the arms raised to her chin and her legs folded under at the knees. Add guidelines for her face and the neck. Add a small blob next to Goldie—this will become a bird.

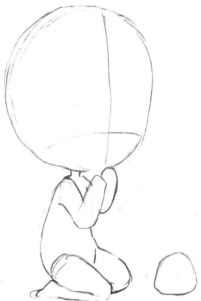

3 Draw the doglike ears and tail; golden retrievers have floppy ears and fluffy tails. Draw the curve on the inner corner of the ear to show that it is folded over. When drawing tails, make sure they branch out from the spinal cord. Sketch in Goldie's face, making her eyes wide—she is looking at that bird and wondering what it is doing there. Add some feathers and a face to the bird.

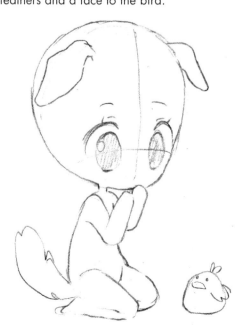

4 Goldie needs some hair and clothes to complete her look! Let's give her straight, thick hair with bangs and a hair bow—giving her a shorter hairstyle will help make her head look bigger and more puppy-like. She wears a sleeveless polo shirt and pleated miniskirt.

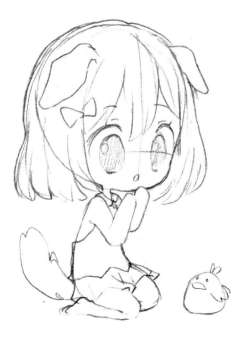

5 Our sketch is messy—clean it up with your eraser! Add some drops to highlight her shocked emotion, and make sure the bird looks like a baby chicken. Add more details, such as clothing folds and seams and strands of hair.

6 Using your fineliner, go over your pencil lines. Draw in the lines, making sure to vary the thickness to add more depth. When drawing the hair, press lighter toward the ends of the strands. Make sure the ink is dry before you begin erasing the pencil lines.

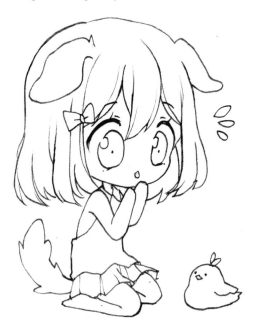

7 Let's add some base color! Using the Spanish Orange and Sienna Brown pencils, color in Goldie's hair and tail, going over the areas several times—using the Sienna Brown pencil at the ends serves as both gradient and shading. Don't forget to color in the baby chicken! Color her skin with the Peach pencil, avoiding the whites of her eyes and the center of her face. Using Apple Green, color in Goldie's irises, adding a dash of True Blue (also use this color for the drops!). Color in her hair bow and skirt with Pink, and use Parma Violet to add shading to the bow and skirt, as well as her shirt.

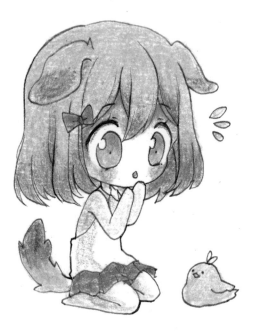

8 Now that we have the base color down, let's blend. If you prefer a traditional pencil look, skip this step; otherwise, using the White pencil, blend all the colors together. To do this, first press firmly with the pencil and go over the whole area in a "straight-lines" fashion (see page 40), then press lightly going over it again in a circular motion. Try to avoid the fineliner lines; you may need to use your fineliner to go over some lines that have become too faded. Use the Parma Violet pencil to re-shade in some areas that may have become too faded, as well as the darker parts of her hair.

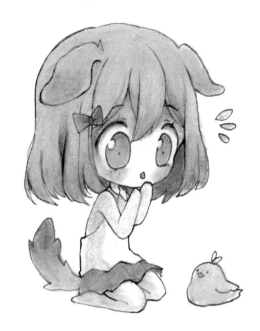

DRAW YOUR OWN! ♥

cotton

Cotton is a fox, so why is she pink? No one really knows the answer to that; however, in the world of chibis, anything is possible.

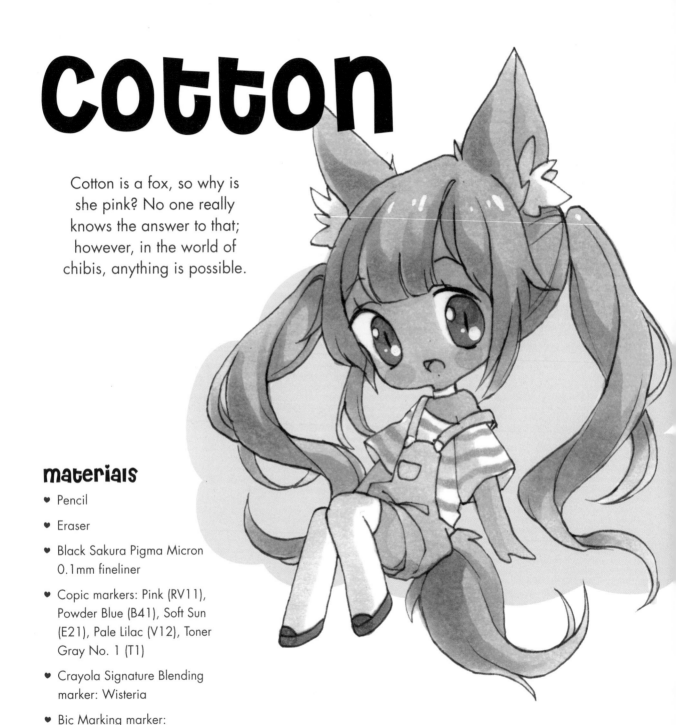

materials

- ♥ Pencil
- ♥ Eraser
- ♥ Black Sakura Pigma Micron 0.1mm fineliner
- ♥ Copic markers: Pink (RV11), Powder Blue (B41), Soft Sun (E21), Pale Lilac (V12), Toner Gray No. 1 (T1)
- ♥ Crayola Signature Blending marker: Wisteria
- ♥ Bic Marking marker: Oceanview Blue
- ♥ White Uni-ball Signo gel pen

1 Using a pencil, draw a large oval for the head and a trapezoid shape for the body that slightly bends at the waist. Cotton is facing to the left (well . . . *your* left and her right side).

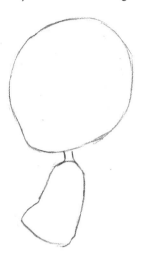

2 Draw Cotton's arms and legs as if she is leaning back on her arms, with her knees bent. Leave some space underneath for her tail! Add guidelines for her face and the neck.

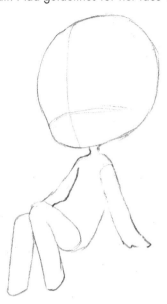

3 Draw the foxlike ears and tail. Fox ears are similar to cat ears, but longer and wider. Don't forget the little fur inside the ear! When drawing tails, make sure they branch out from the spinal cord. Sketch in Cotton's face so she's looking at you.

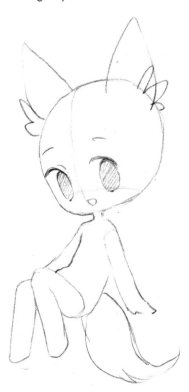

4 Cotton needs some hair and clothes to complete her look! Let's give her blunt bangs with loose tendrils and long, twisty pigtails that are flowy and bouncy. She wears a baggy T-shirt, short overalls, and loafers. Don't forget to add a little pocket on the overalls so she can hold things in there.

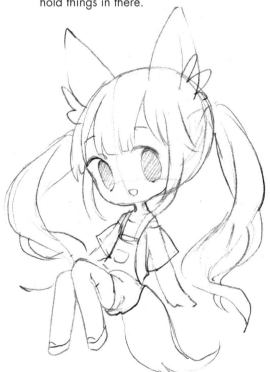

5 Our sketch is messy—clean it up with your eraser! Let's refine the shape of Cotton's tail a little more, so it looks less like a mophead. Add more details, such as clothing folds and seams and strands of hair.

6 Using your fineliner, go over your pencil lines. Draw in the lines, making sure to vary the thickness to add more depth. When drawing the hair, press lighter toward the ends of the strands. Make sure the ink is dry before you begin erasing the pencil lines.

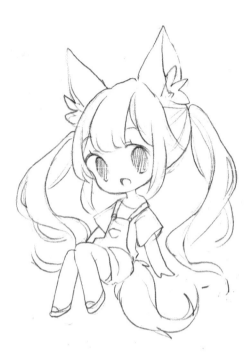

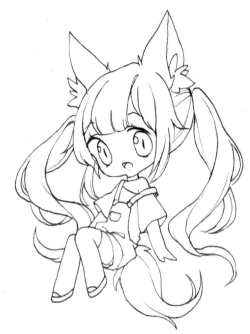

7 Let's add some base color! Using your Pink Copic marker, color in Cotton's hair, tail, and overalls pocket. Use the Powder Blue Copic marker for the overalls and the Wisteria Crayola marker for her eyes and shoes. Color in her skin and the inside of her ears with the Soft Sun Copic marker. Make sure to leave her ear fur, T-shirt, and socks white.

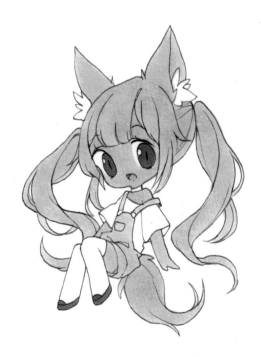

8 Now that we have the base colors down, let's add shading. Use the Pink Copic marker to add shading to Cotton's face, neck, and limbs. Don't forget the inside of her ears and dots for blush on her face! Using a blend of your Pale Lilac Copic and Wisteria Crayola markers, shade in her hair, making sure your strokes are going in the same direction. Add some blue tints to the shaded areas with the Powder Blue Copic marker to serve as contrast points. Using your Oceanview Blue Bic marker, add shading to Cotton's eyes, overalls, and shoes. With the Pale Lilac Copic marker, draw stripes on her T-shirt. Using the Toner Gray No. 1 Copic marker, shade in all the white areas. Finally, use the white gel pen to add some highlights to Cotton's hair and eyes.

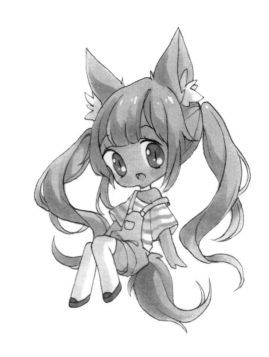

DRAW YOUR OWN!

Devin

Bats are nocturnal, so don't expect to "hang" out with Devin during the day! If you do encounter a bat during the day, it's probably best not to interact with it.

materials

- ♥ Pencil
- ♥ Eraser
- ♥ Black Sakura Pigma Micron 0.1mm fineliner
- ♥ Copic markers: Skin White (E00), Pink (RV11), Toner Gray No. 1 (T1)
- ♥ Bic Marking markers: Sunset Orange, Misty Blue, Polynesian Purple
- ♥ Touchnew marker: BG3
- ♥ Crayola Signature Blending markers: Slate, Wisteria
- ♥ White Uni-ball Signo gel pen

1 Using a pencil, draw a large oval for the head and a trapezoid shape for the body that slightly bends near the chest—Devin is facing to the right (well . . . *your* right and his left side).

2 Draw Devin's arms and legs as if he is leaning backward, with his arms straight down his sides and the left leg bent at the knee and the right foot pointing up. This pose makes him look active. Add the neck.

3 Add the guidelines for the face. Make his ears long and pointy like bat ears—these are the same type of ears used on vampire characters. Sketch in his face—let's give Devin an expression that is a mix of surprise and confusion, as he's probably not too happy to see you right now. Draw upside-down arcs from Devin's shoulders and at the tips, make 3 branches that fan out in the same direction. These will be the base of his wings. Don't forget to add a long, thin tail! When drawing tails, make sure they branch out from the spinal cord.

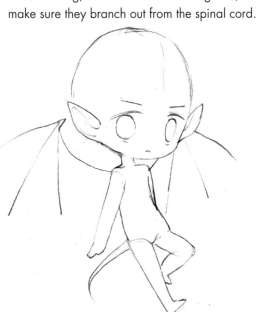

4 Devin needs some hair and clothes to complete his look! For his hair, start with a part on the side of his head, branching out the hair to swoop down over one side of his face, while keeping his hair short and tidy on the other side. Draw a casual dress shirt and jeans, ensuring that the tie is flipped upward slightly to indicate movement and make it look more realistic. Draw curved lines at the bottom of the wing "branches" for the skin on his wings. If you are having trouble with the wings, try thinking of them as umbrellas!

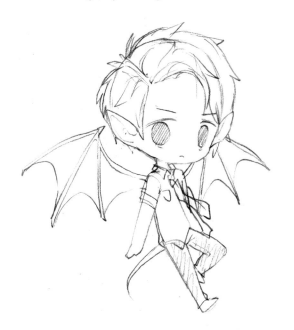

5 Our sketch is messy—clean it up with your eraser! Be sure to add some details such as clothing folds, seams, pockets, and buttons.

6 Using your fineliner, go over your pencil lines. Take special care when lining the small details, such as on the wings and jeans—it might help to press lightly at first, and then go over it again if you want a thicker line. Draw in the lines, making sure to vary the thickness to add more depth. When drawing the hair, press lighter toward the ends of the strands. Make sure the ink is dry before you begin erasing the pencil lines.

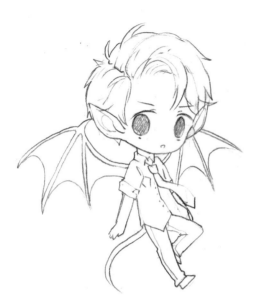

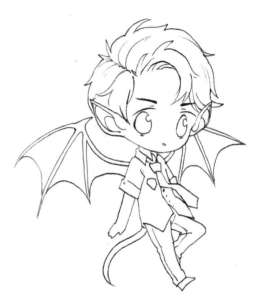

7 Let's add some base color! Using the Skin White Copic marker, color in Devin's skin, avoiding the whites of his eyes. Color in his eyes, tie, and shoes with the Sunset Orange Bic marker. Using the Touchnew BG3 marker marker, color in his hair, wing branches, and tail. When coloring his hair, be sure to start from the inside and drag your marker outward. Use the Crayola Slate marker for the insides of the wings and Bic Misty Blue for his jeans.

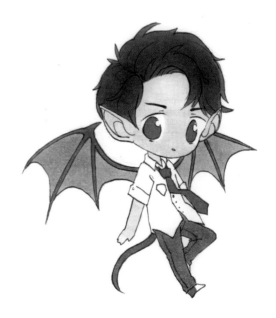

8 Now that we have the base color down, let's add some shading. Using your Pink Copic marker, add shading along his hairline, inside his ears, and on his cheeks and arms. Shade in his eyes and tie with Crayola Wisteria and the white shirt with Copic Toner Gray No. 1. Add shading to the backs of his jeans and underside of his hair with the Polynesian Purple Bic marker. Finally, use the white gel pen to add some highlights to Devin's hair and irises.

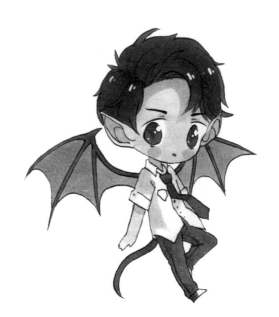

DRAW YOUR OWN!

Dot

Ladybugs are known for their dots, but they're not all ladies. Though Dot is a giant ladybug, she is harmless, which is what these cute insects are known for.

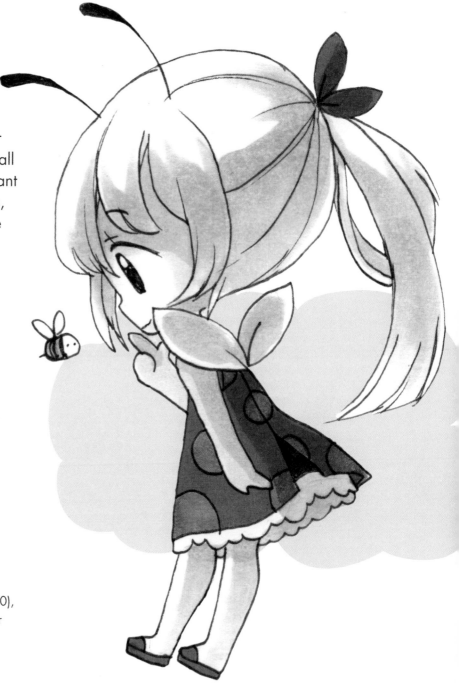

materials

- ❤ Pencil
- ❤ Eraser
- ❤ Black Sakura Pigma Micron 0.1mm fineliner
- ❤ Bic Marking markers: Sunset Orange, Summer Melon, Polynesian Purple
- ❤ Touchnew marker: WG3
- ❤ Copic markers: Skin White (E00), Toner Gray No. 1 (T1), Powder Blue (B41), Pink (RV11)
- ❤ White Uni-ball Signo gel pen

1 Using a pencil, draw a large oval for the head and a trapezoid shape for the body that slightly bends near the chest—Dot is facing to the left (well . . . *your* left and her right side).

2 Draw Dot's left arm bent up in a thinking position and her legs rocking back, with her feet pointing up. Add the guidelines for the face, defining the nose on her lower face. Draw the neck and an ear for a reference point for the body tilt—it can be erased later.

3 Sketch in her face—let's give Dot a delighted expression, as she will be looking at a bumblebee. Draw the simple antennas and delicate insect wings.

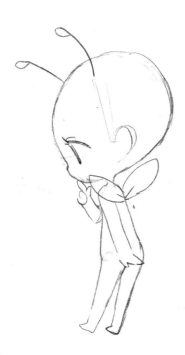

4 Dot needs some hair and clothes to complete her look! Let's give her long bangs with loose tendrils and a long ponytail fastened with a tie that matches her wings. Add lines in her hair that connect to where her ponytail is tied up—this is to indicate which direction her hair is going. She wears a sleeveless sundress with a back pleat and frilly underlayer and flats. Add a cute bumblebee!

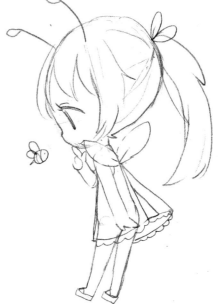

5 Our sketch is messy—clean it up with your eraser! Add some more detail; ladybugs have spots on them, so add them to her dress.

6 Using your fineliner, go over your pencil lines and color in her eyes, antenna, and the pleat of her dress. Draw in the lines, making sure to vary the thickness to add more depth. In areas where many lines meet, you might want to go over some of those lines a second time. When drawing the hair, press lighter toward the ends of the strands. Make sure the ink is dry before you begin erasing the pencil lines.

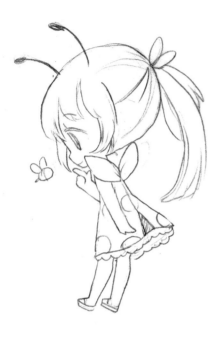

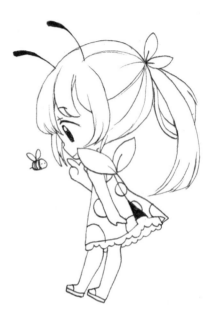

7 Let's add some base color! Using your Bic Sunset Orange marker, color in Dot's hair tie, dress, and shoes. Color the spots on her dress with the Touchnew WG3 marker and the bee with Bic Summer Melon. Using the Skin White Copic marker, carefully add some color to her face, starting from the edges of her face inward, avoiding the whites of her eyes. With her legs and arms, start from the top moving downward, making sure to press lightly.

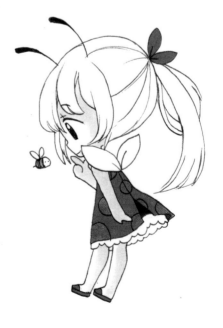

8 Now that we have the base color down, let's add some shading. Shade in all of the red and gray parts with Bic Polynesian Purple, ensuring that the shading stays on the right and bottom sides at all times. Using a blend of the Copic Toner Gray No. 1, Powder Blue, and Skin White markers, shade in her hair, wings, and dress underlayer. Since the light is coming from the top left, avoid shading in those areas. Finally, use Copic Pink along her hairline and on the backs of her arms and legs.

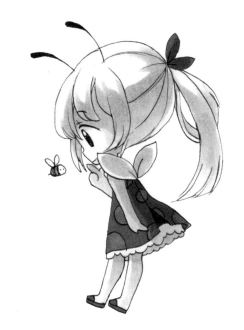

DRAW YOUR OWN!

inspiration gallery

Now that you know how to draw chibis, put your imagination to work and create your own characters! This gallery is here to inspire you with all aspects of your chibis, including eyes, hairstyles, clothing, props, and much more.

eyes

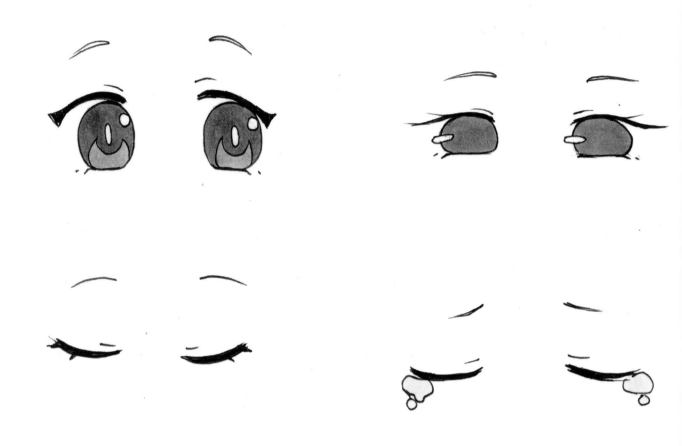

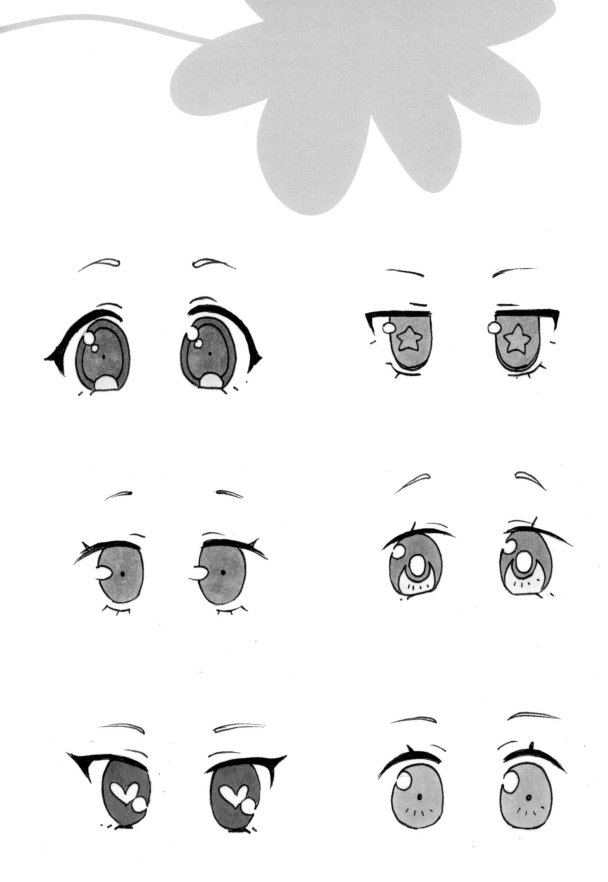

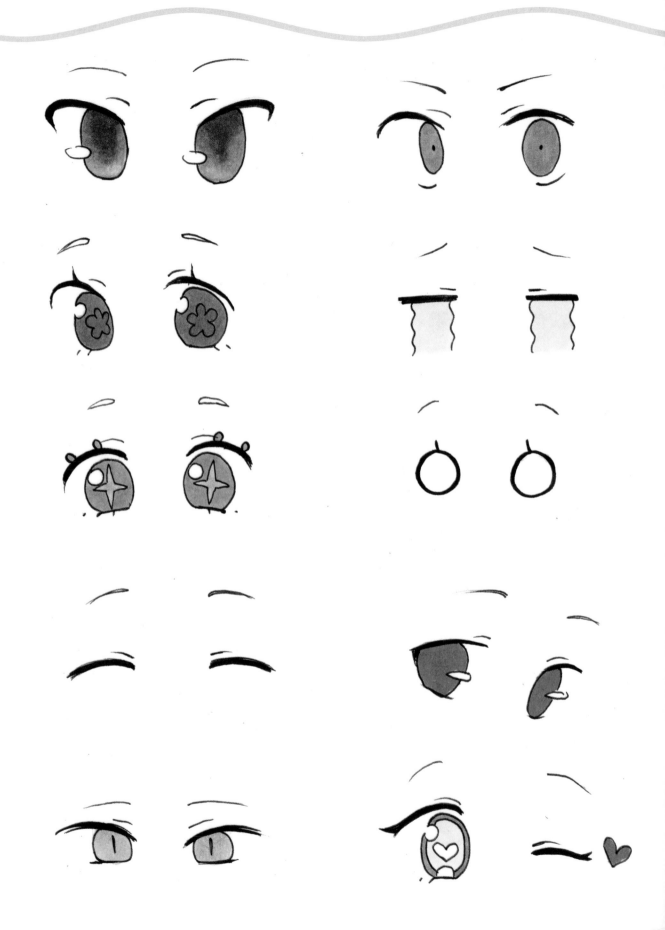

hairstyles

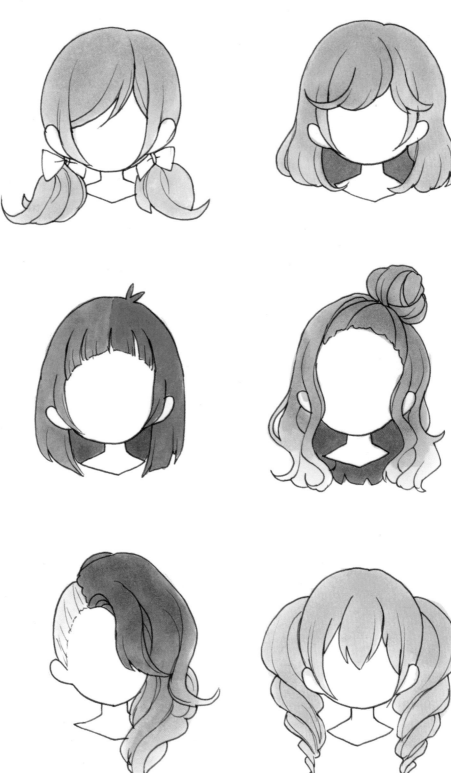

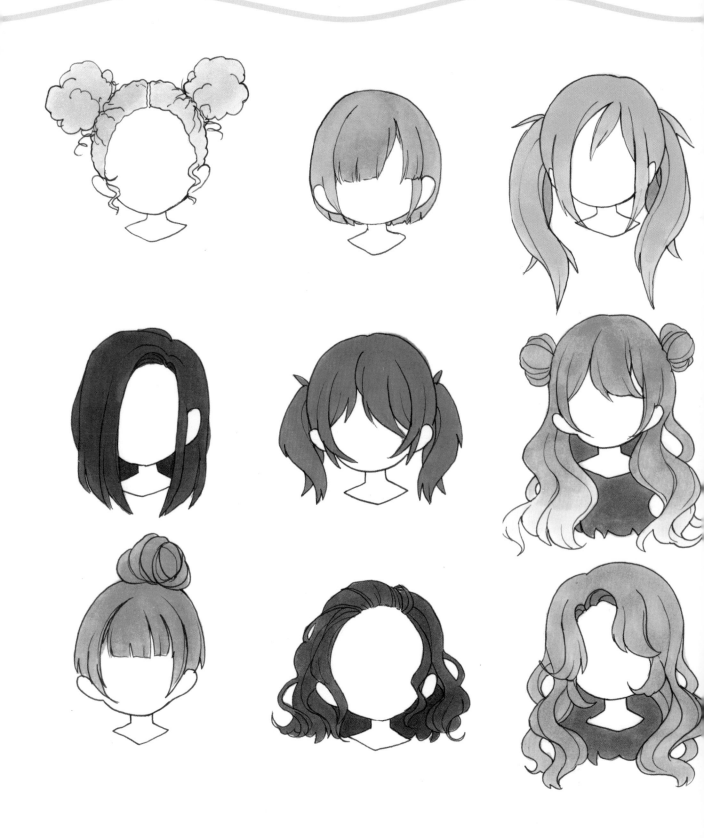

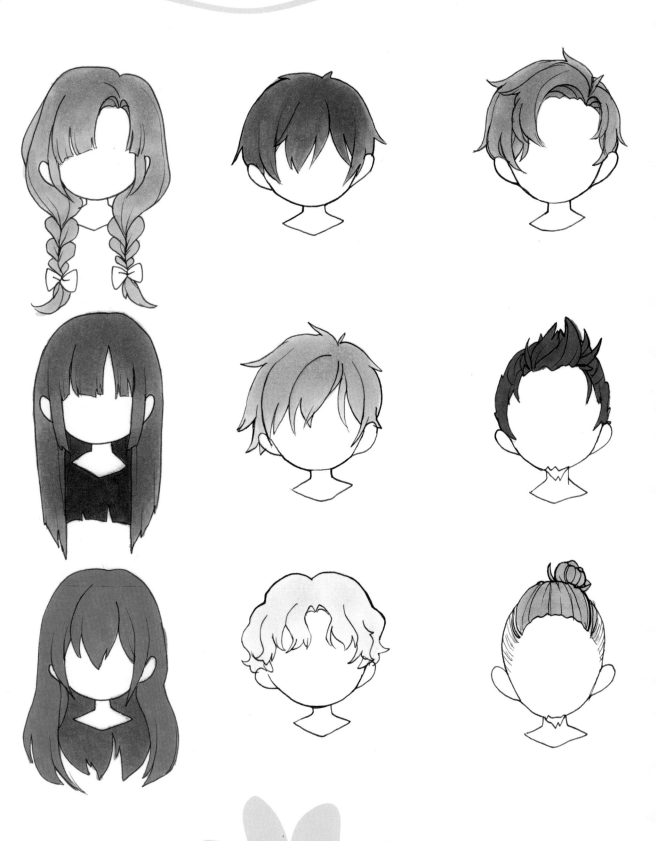

clothing

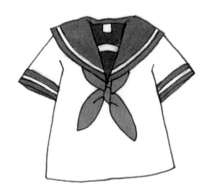

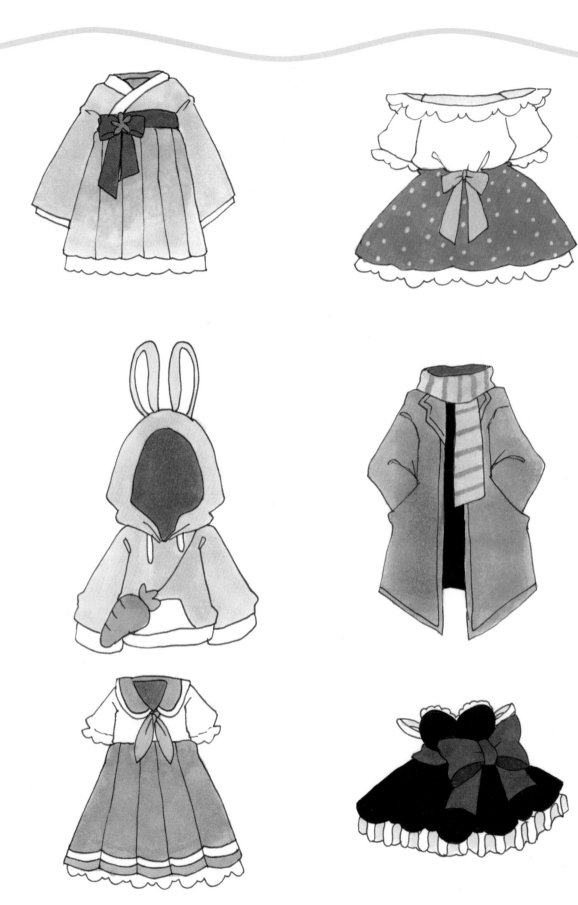

Props and Accessories

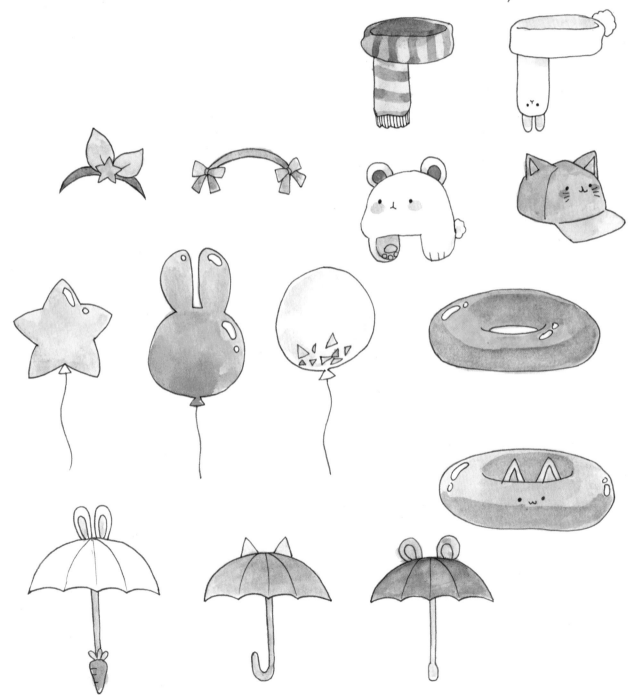

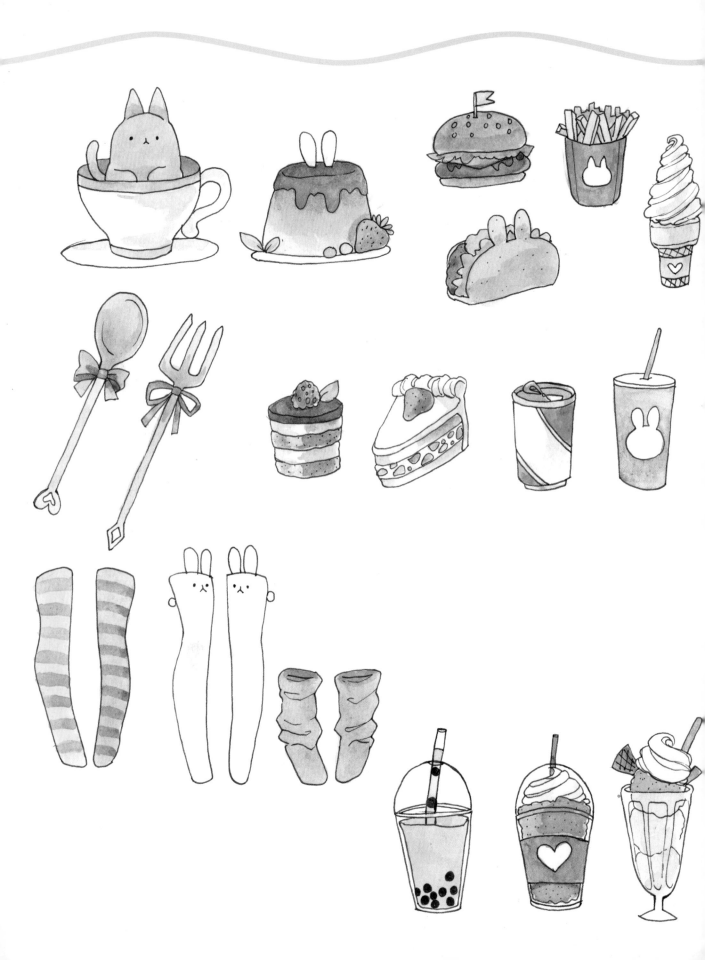

ears and Tails

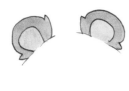

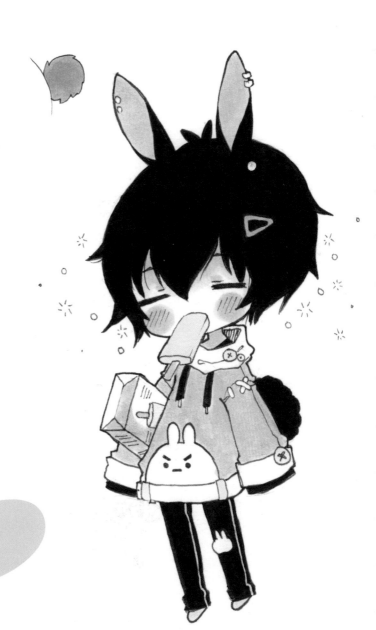

Practice and Coloring Pages

These pages include body forms for drawing your own chibi characters, as well as chibis for you to practice coloring and shading with markers, colored pencils, or watercolors. Mistakes welcome!

DRAW YOUR OWN

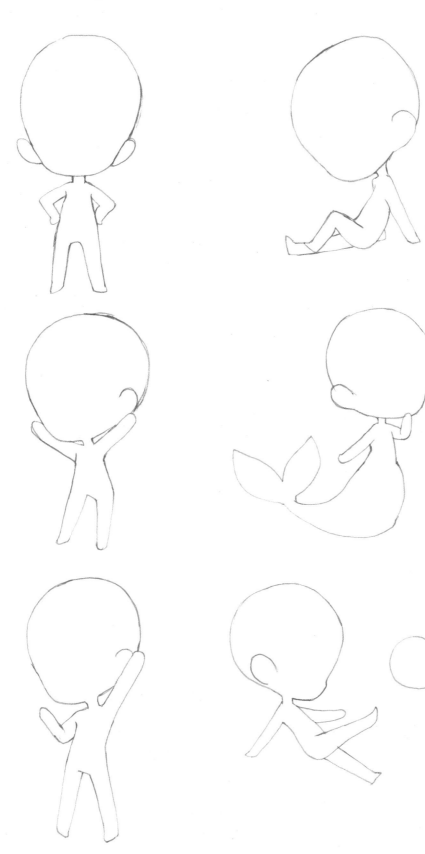

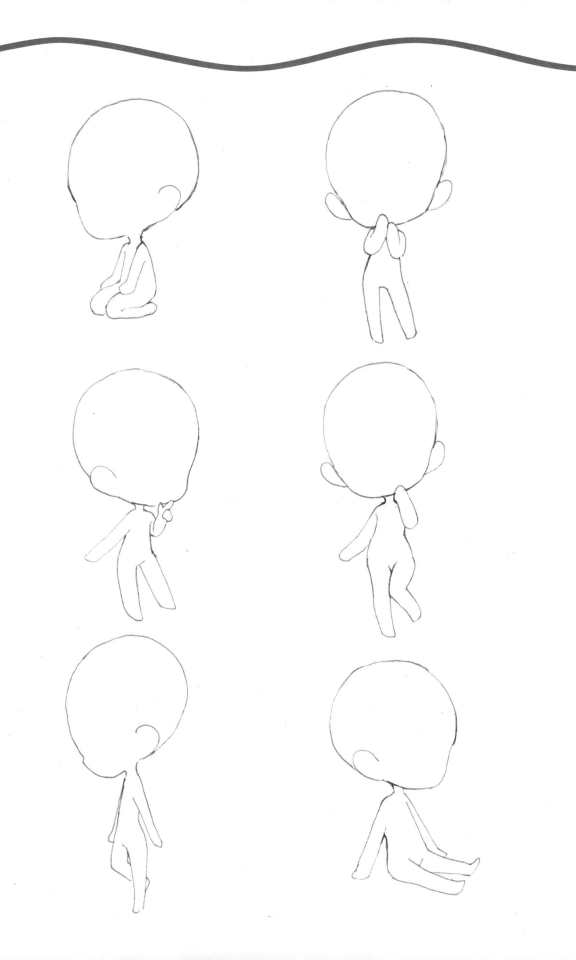

COLOR YOUR OWN